1979

Anthea Peppin and
William Vaughan

# FLEMISH PAINTING

PHAIDON

For Rosamund

*Phaidon Press Limited, Littlegate House, St Ebbe's Street, Oxford*
*Published in the United States of America by E. P. Dutton, New York*

*First published 1977*

© *1977 Elsevier Publishing Projects SA, Lausanne/Smeets Illustrated Projects, Weert*

*ISBN 0 7148 1747 3*
*Library of Congress Catalog Card Number: 77-73886*

*Printed in The Netherlands*

# FLEMISH PAINTING

When in 1456 the Italian scholar Bartolommeo Fazio called Jan van Eyck 'the leading painter of our time' he was paying a remarkable tribute. For as a humanist scholar, Fazio was part of a movement fundamentally opposed to the northern 'gothic' world to which Van Eyck still belonged. His praise is evidence that then, as now, the Flemish master's miraculous skill was sufficient to override all prejudices of taste.

The reputation for technical brilliance that Van Eyck achieved for Flemish painting was long lasting. It survived – with occasional lapses – throughout the period covered by this book: that is, up to the death of that incomparable virtuoso, Peter Paul Rubens, in 1640. So great was the fame of Flemish art during these centuries that accomplished painters from other parts of northern Europe were frequently referred to as 'Flemings'. Even in a literal sense, the domain of Flemish art was greater than that of the south Netherlandish province from which it took its name. In the early fifteenth century the main centres where this type of art was being produced – the prosperous cities of Bruges and Ghent – were actually in Flanders; but by the sixteenth century the impetus had moved to the new commercial centres of Antwerp and Brussels in neighbouring Brabant. And at all times there were major painters practising in these provinces who originated from other parts of the Netherlands and from the lower Rhineland. The art of the northern Netherlands was also closely related; and while a provincial 'Dutch' style is discernible in these regions, it does not make sense to talk of an independent Dutch school before the late sixteenth century, when the revolt against Spanish rule and Catholicism was causing the north to reform as an independent republic. It is for this reason that such great innovators as Geertgen tot Sint Jans, Hieronymus Bosch and Pieter Aertsen, who did work in the area that is now part of modern Holland, are included in this book. For they formed an integral part of an artistic milieu that had its main focus in the 'Flemish' south.

Whilc maintaining a high tcchnical standard, Flemish painting was not consistent in its stylistic development. Looking from the minute precision of Van Eyck to the exuberant brilliance of Rubens, one might conclude that change, rather than progress, was the order of the day. There is no integrated sequence of the kind that one associates with Italian art in these centuries. Part of the reason for this seems to have been the Flemings' reliance on dexterity. Unlike the Italians, they had little interest in theory. While the Florentines of the fifteenth century set out to perfect realistic representation through a judicious application of learning – through study of the antique, anatomical dissection and the evolution of a mathematical system of perspective – the Flemings did so empirically. Their great innovation was the refinement of the technique of oil painting, which they used to reproduce the surface appearance of things – from the nearest detail to the most ethereal distance – with unprecedented fidelity.

For a time the two tendencies ran parallel, and the Flemish remained blissfully unconcerned about the innovations of the Italians. By the time of Leonardo, Raphael and Michelangelo in the early sixteenth century, however, this isolation could no longer be maintained; and there followed a prolonged and uneasy period of readjustment.

For most people the fifteenth century, dominated as it is by Jan van Eyck, Rogier van der Weyden and Hugo van der Goes, is the most alluring period of Flemish art. It was a time of spiritual and material security, when the Low Countries still shared a common faith and were still governed by the Dukes of Burgundy, who were, for the most part, intimately concerned for the well-being of this their richest possession. In 1477 the Netherlands passed by marriage to the Habsburgs – the family from which the Holy Roman Emperor was traditionally chosen. Up to 1530, however, they were administered by governors who sought to maintain the old Burgundian principles; and only gradually did the provinces become implicated in the Habsburgs' wider ambitions.

3

The court of the Duke of Burgundy appears to have been the place where that peculiar fusion of elegance and naturalism typical of early Flemish art first occurred. Many Flemings were employed there, and in their hands the decorative International Gothic style took on a more realistic direction. This may well have been the milieu from which Jan van Eyck emerged. After working for Count John of Holland at The Hague, Van Eyck was made 'painter and equerry' to Philip the Good in 1425. It is commonly believed that he illuminated Books of Hours in the early part of his career. This would certainly account for the delicacy and refinement that pervades all his panels – even the vast and complex polyptych, the Ghent altarpiece (Plate 6). It is hardly surprising that he was known for so long as the 'inventor' of oil painting. For he saw the potential of the medium as no one had done before, and used it to combine fineness of detail with richness of textures and nuances of light in a way that has never been surpassed. He is one of those rare artists whose fascination lies in his sheer powers of description. His figures are static and emotionless, his understanding of anatomy and space limited, but his feeling for the way light falls on objects never fails. It is this which gives such conviction to the *Arnolfini Marriage* (Plate 4). Here, even the light in the extreme foreground, which cannot possibly come from the window behind the figures, is accounted for. For, as the mirror shows, there is an open door between us and the couple in the picture.

Van Eyck's technique involved countless layers of transparent paint being placed over a panel covered with a white chalk ground. By this means, light could penetrate and be reflected back through the paint to produce a rich glow. It was a laborious method, involving months of painstaking work. If such fineness was encouraged by the taste of the court, it was fully supported by the pride in craftsmanship to be found in the towns, where quality was protected – as in other trades – by the guilds. These assured thorough training and practice, and governed the nature and quality of the tools and materials to be used.

The taste of this bourgeois world was more fully represented by a slightly older contemporary of Van Eyck. This was the 'Master of Flémalle', now usually identified as Robert Campin (Plates 1 and 2), active in Tournai between 1406 and 1444. Campin's art showed a different concept of realism from that of Van Eyck, and one that was equally vital for the Flemish school. It depended not so much upon illusionistic effects as on naturalistic types. Even his holy personages come across as human characters, and it is significant that they are rarely shown with such indications of the supernatural as haloes. What his art lacked in refinement, it gained in expressive vigour. In his pupil Rogier van der Weyden (Plates 7, 9 and 11), who settled in Brussels after completing his apprenticeship in 1432, such expressiveness reached a new subtlety. His masterpiece, the *Descent from the Cross* (Plate 7), conveys a depth of feeling that makes him the finest painter of the mid-century.

Van Eyck was not so fortunate in his immediate successor, Petrus Christus (Plate 5). For this painter, who was the principal master in Bruges between 1444 and 1472/3, copied Van Eyck's manner in a way that lost much and added little more than naïve charm. However, personal contacts soon ceased to be of much import. The principal works of these masters were altarpieces, which were on view for anyone to see, and there were few painters in Flanders after 1440 who did not owe a profound debt to both Van Eyck and Rogier van der Weyden. This can be seen, for example, in the work of Dieric Bouts (Plate 3), a painter from the north who settled in the university town of Louvain in 1450, and who was fully conversant with the achievements of his illustrious predecessors. For later masters, particularly those coming to maturity after 1460, the main problem was one of innovation. Many were content simply to paraphrase and refine; as was Memlinc (Plate 12), the suave German-born master of Bruges, active from about 1465 to 1494. Others, however, sought new modes of expression. This was certainly the case with the Ghent master, Hugo van der Goes (Plates 14 and 16), active 1467–82, and famed for his *Portinari Altarpiece*, the most ambitious work of his generation. Unfortunately, the religious emotion that can be felt in this nativity turned to melancholia, and he died, insane, some years after having sought refuge in a monastery.

The *Portinari Altarpiece*, a work destined for Florence, is unusual amongst Flemish paintings both for its size and for the scale of its figures. Monumentality was not encouraged in Flanders. The very technique of the artists was more suited to jewel-like perfection than to breadth and grandeur. Furthermore, there was little opportunity in the churches of the north – with their large windows and limited wall space – for those large narrative cycles that were to generate the Grand Manner in Italy.

The Flemish were also more limited than the Italians in their subject-matter. They were not asked to supplement traditional devotional themes with those reconstructions of classical subjects so dear to the humanists of the south. Indeed, the only secular art of any significance in the north at this time was portraiture. This genre seems to have been nurtured more on a late gothic sense of individualism than on any humanist exaltation of the human type. Certainly, identification rather than idealization seems to have been the primary concern in Van Eyck's records of the unlovely features of wealthy burghers and court officials. Many of these depictions took the traditional form of the representation of the donor in an altarpiece (Plate 8). But Van Eyck also developed a new type of head and shoulders portrait in which an individual's features and character could be more closely studied. Significantly, this was one of the few Flemish picture types that was adopted by the Italians.

Another important development in Flemish art was the growing awareness of landscape. The love of naturalistic detail was a characteristic feature of gothic art. It is not hard to trace in the vignettes of illuminated manuscripts the source of those airy vistas and detailed plants to be found in the work of Van Eyck. In succeeding generations, the contrast of the infinite and the infinitesimal gave way to a more subtle elaboration of the middle ground. By the end of the century this had become – in the hands of the innovator Geertgen tot Sint Jans, a Haarlem painter who died at the age of 28 – a convincing continuous environment (Plate 17).

Despite these changes, there was more a feeling of ending than of beginning in the Netherlands at this time. In the deeply conservative city of Bruges, traditions were being drawn to a close – not ingloriously – by Gerard David (Plate 15). Elsewhere, the waning medieval world was viewed with less equilibrium. A sense of impending doom was not uncommon throughout Europe around 1500 – the year tipped by many for the Second Coming of Christ. This seems to have nurtured the bizarre imagination of Hieronymus Bosch. Living in the provincial capital of north Brabant, his attitude to change was largely defensive; and his curious imagery is full of pungent satires against those who put this world before the next (Plates 18–20). But this last strident affirmation of medieval faith was already being superseded in the artist's lifetime by the new practical Christian humanism of Erasmus. It was not long before Bosch's pictures were admired in the Netherlands less for their grim moral warnings than for their drolleries.

By the end of the second decade of the sixteenth century, there had taken place many other changes which reinforced the cultural impact of the new humanism. With the accession of Charles V as Holy Roman Emperor in 1519, the Netherlands became part of a realm that spread throughout Europe and the newly discovered Americas. Even before this, the country had been profiting from the wider scope opened up by the Habsburg connection. Antwerp – for a long time rising in importance at the expense of the more restrictive city of Bruges – now became the richest trading centre in Europe. But there were soon to be tragic problems. From another part of the Empire – Germany – there spread the impact of the Reformation, that rebellion against the old religion which was to split Europe. By the end of the sixteenth century this had involved the Netherlands in a ruinous conflict with its rulers.

As Antwerp rose in commercial importance, so it became, and remained, the artistic centre of the southern Netherlands. Here the 'Antwerp Mannerists' first attempted to realign the art of their country in accordance with recent styles in Italy. Some of these painters, notably Mabuse (active 1503–32), had actually been to Italy. But for others, a more convenient source of inspiration came through engravings – either those made

directly from Italian works, or the masterly prints of Dürer, which presented the achievements of the Renaissance in a form more palatable to northerners. Their uneasy fusion of late gothic motifs with classical imagery and High Renaissance gestures bears little relation to the conscious stylization which gripped Italy in the wake of the High Renaissance. Like Italian Mannerism, however, it was to remain a dominating tendency for the rest of the sixteenth century.

The complex developments of the sixteenth century can only be hinted at here. In general it can be said that the growing importance of secular subjects and the attempts to assimilate Italian art forms precipitated a fragmentation of subjects that was to become a standard feature of European art for the next four centuries. For this was the time when artists began to emerge as specialists in certain types of subject, or 'genres'. History painting was considered supreme amongst these, and was followed by the 'lesser' genres of portraiture, low-life or 'genre' painting, landscape, and still-life. The very concept of history painting, that is, the treatment of historical, devotional or allegorical subjects in an idealized manner, was dependent upon the culture of the Renaissance. Hence it is hardly surprising to find it held supreme by those artists most in contact with Italian culture, namely the 'Romanists' – artists who had been to Rome. The esoteric and intricate historical art of these painters must always have been a minority taste; it is certainly so today. Yet it must be remembered that those other lesser genres, which are for us so much more appealing, existed in the shadows of this 'high' art, and were in many ways conditioned by it.

Most of the Romanists grudgingly practised portraiture. The reason for this was largely financial. The demand for portraits – bringing ample remuneration – from the wealthy burghers and court at Brussels could not be ignored. The reputation of the Flemish portrait had in fact remained high throughout all the unsettling changes. Such masters as Massys (Plate 22) had superbly adapted the old half-length portrait type to the requirements of the new age. Later masters like Frans Floris (Plate 26), a leading Romanist in Antwerp in the 1540s, show a tendency towards the style of Venetian portraits, combining *gravitas* with sharp-eyed realism. This style was to have immense importance for later Flemish painting, for it represented the point at which the Venetians' freer handling of paint became associated with Flemish art – an association that Rubens and Van Dyck were to take so much further.

Portraiture developed as a kind of involuntary accompaniment to history painting; genre painting, the depiction of the folk world of peasants, with its legends, coarseness and drolleries, emerged as a contrast to the depiction of the ideal. This opposition can be seen in a most curious way in the art of Pieter Aertsen (Plate 24), an Amsterdam artist trained in Flanders, who visited Rome and absorbed the technique and aspirations of the Romanists. In the 1540s he began to supplement his idealized religious paintings with luscious still-lifes and scenes depicting everyday events. What started perhaps as a conceit grew into an obsession, to the point where the depiction of peasant life predominated, forcing the religious scenes into the background and finally out of the picture altogether.

It is significant that the greatest Flemish painter of the sixteenth century – Pieter Bruegel the Elder (Plates 27–31) – was a specialist in genre painting, and one who avoided painting religious subjects in an idealized manner. Curiously, Bruegel was also a Romanist; but when he returned from Italy in 1554, settling first in Antwerp and later in Brussels, he did not make pastiches of Italian art, but approached the traditions of his own country with renewed understanding.

One of the sources of Bruegel's effectiveness is his sensitive use of landscape. Again, it was in the Netherlands that landscape emerged as a separate genre. Joachim Patenir, who was active in Antwerp from about 1515 to 1524, appears to have been the first artist to be described as a 'landscape painter', when the German artist Dürer referred to him as such in 1521. By this time he was well known, not simply for painting the backgrounds of other people's pictures, but also for fantastic panoramic views in which the figurative subject was reduced to a minor incident (Plate 21). Gradually such fanciful 'world pictures'

became modified by the inclusion of more familiar scenes in the foreground, a development certainly to be found in the works of Pieter Bruegel the Elder (Plate 31), and carried on by his sons Pieter II and Jan (Plate 33).

Yet the fully developed landscape formula, with its articulated foreground, middle ground and background, does not emerge until artists such as Gillis van Coninxloo (Plate 32) towards the end of the century. Coninxloo's experiences in Germany – he was for a time a refugee at Frankenthal – seem to have inspired him with a love of foliage that encouraged him to use foreground trees to articulate the composition in a manner that was soon to become standard amongst landscape painters. Like many of his generation, Coninxloo eventually settled in the northern provinces and became a formative influence in the newly emergent 'Dutch' school. The reasons for such emigrations were political rather than aesthetic. For ever since the Netherlands had been inherited by Philip II of Spain, they had been subjected to a rigorous régime of religious orthodoxy, which led in 1566 to iconoclasm and open rebellion. From this time on, the Netherlands were plunged into a civil war that increasingly destroyed the prosperity of the region. Like other skilled workers, artists left the Netherlands in great numbers, either for reasons of faith or simply to find securer employment.

It was more or less by chance that the greatest Flemish artist of the seventeenth century, Peter Paul Rubens, actually ended up working in Flanders. For Rubens was born into an Antwerp family that had emigrated to Germany. Although they had returned by the time Rubens was eleven, he was later to go to Italy, where he became court painter to the Duke of Mantua. Coming back to Antwerp on account of the death of his mother in 1608, he was persuaded to stay by a court appointment and by the news of the signing of the Twelve Years Truce (1609–21) – the cessation of hostilities promising a return of prosperity to the country.

Rubens's return was fortunate, for, like Bruegel, he seems to have thrived best in his native land. In Italy he had been influenced not only by the masterpieces of the Renaissance, but also by those innovators of the new dramatic manner of the Baroque. However, it was only in Flanders that these experiences were fused into a coherent style and his art took on that ease and vibrancy for which it is famed. A devout Catholic and patriot, Rubens was employed by Church and court, creating altarpieces (Plate 36) and large decorative schemes, in celebration of the return of peace and orthodoxy. He himself thoroughly enjoyed the intellectual and technical challenge of such works, and was to provide a similar service for monarchs abroad as his reputation grew (Plate 38). To deal with such great undertakings he assembled a body of assistants, who virtually constituted a factory for the production of large canvases. Amongst these were many – such as Frans Snyders, Jacob Jordaens, and Anthony van Dyck – who were major masters in their own right. It says much for their employer that the experience of this work seems to have brought out, rather than suppressed, their personal styles: Jordaens developing a slightly coarse, earthy ebullience (Plate 39), and Van Dyck that elegant brilliance which made him one of the greatest court painters of all time (Plates 40, 41 and 48). Both by his own reputation and by stimulating other artists in this way, Rubens re-established Antwerp as a major art centre, though for the last time.

While his central concern was history painting, Rubens was adept at almost every genre – landscape (Plate 42), portraiture (Plates 34 and 35), hunting scenes, and peasant life. Only one current picture type seems to have held no attraction for him, and this was flower painting. Perhaps this was because flower painting was the only genre in which something of the meticulous technique of the early Flemish masters still survived. Certainly, when one looks at one of the canvases on which he collaborated with a flower specialist – such as Jan Brueghel the Elder (Plate 46) – one is aware of the great changes in handling and scale that Flemish painting had undergone.

When Rubens died in 1640, the Flemish school, like Flanders itself, was unmistakably in decline. Eight years later the Treaty of Westphalia sealed the country's fate. For not only did this treaty recognize the independence of Holland, it also ensured that the

economic ruin of Flanders would continue, by keeping Antwerp's outlet to the sea, the Scheldt, closed to trade. The country had to suffer many vicissitudes before it emerged, after 1830, as the modern state of Belgium.

In this collapsing world, the art of the Flemish seems finally to have lost its vitality. Adriaen Brouwer, the only artist of the younger generation who showed signs of continuing a boisterous manner in his genre painting, died young in 1638. Those minor masters who survived late into the century – such as David Teniers the Younger (Plate 43) – are hardly distinguishable from their Dutch counterparts. It is true that there is a hint more bravura and colour in their manner – but this now looks weak beside the more sober and penetrating realism of the Dutch – like a fading bunch of flowers.

If Rubens's work had no sequel in Flanders, his example was to remain a generative force in European art for many centuries. Already in the seventeenth century his work was spoken of by French artists as an alternative to the classical art of their own countryman, Nicolas Poussin, who was idolized by their Academy; and he was to remain a support for such opponents of academicism as Watteau in the eighteenth century and Delacroix during the Romantic era.

It was remarked earlier that there seemed to be little to connect Rubens and Van Eyck. Yet in the positions that they occupied in their respective times there is perhaps a resemblance. Like Rubens, Van Eyck appears to have been learned, practical and personable. Certainly, both men were sufficiently wide-ranging in their abilities to be used as diplomats as well as artists by their courtly employers. But most important of all, both were men who, despite the evident intelligence that they brought to their art, placed the sheer act of painting above all else. In making it so clear that there was nothing mindless about 'pure' painting, they played a vital role in affirming that Flemish tradition of empirical values at times when European art was in danger of becoming overloaded with theory.

**Plate 1.** ROBERT CAMPIN 'MASTER OF FLÉMALLE' (1378/9–1444): *The Nativity*. About 1430? Panel, 82 × 69 cm. Dijon, Musée des Beaux-Arts.
This picture seems to be based on the description of the Nativity in the 'Revelations' of the recently canonized Bridget of Sweden. The two midwives on the right, however, derive from the apocryphal Book of James. One, Mary Salome, gestures to her right arm, once withered because of her doubt in the Virgin birth and now healed through touching the Child. The decrepit shed is set against a wintry Flemish landscape, which is remarkable for such naturalistic details as the pollarded trees and the long shadows cast by the low sun.

**Plate 2.** ROBERT CAMPIN: *The Virgin and Child before a Firescreen*. Before 1430. Panel, 63 × 49 cm. London, National Gallery.
The idea of locating a religious event in a contemporary setting originated in Italy; however, it is also a typical feature of early Flemish art. Here the plaited rush firescreen acts as a halo, while the richness of the Virgin's robe and the quality of the book she has laid down tell us that this is no ordinary mother. The carved cabinet and golden chalice on the right seem to indicate this also, although these are part of a vertical strip, nearly ten centimetres wide, which has been added in modern times. The realism of the picture is hardly diminished by the oversteep perspective of the floor on the left-hand side, nor by the ambiguous position of the Virgin herself, who must be seated on some sort of footstool in front of the bench.

**Plate 3.** DIERIC BOUTS (living *c.* 1448, d. 1475): *The Entombment*. About 1455? Tempera on linen, 90 × 74 cm. London, National Gallery.
The restrained emotion of the mourners around the tomb is echoed by the artist's control

in the careful grouping of the figures, and in the limited choice of sombre colours used. The mood is one of quiet grief, and this is emphasized by the muted landscape in the background. The unusual technique of tempera on linen – presumably employed to make the work more portable – accounts for the present rather faded appearance of the picture.

**Plate 4.** JAN VAN EYCK (active 1422, d. 1441): *The Marriage of Giovanni Arnolfini and Giovanna Cenami.* 1434. Panel, 81 × 59 cm. London, National Gallery.
In the seclusion of a bedchamber, Giovanni Arnolfini, a Lucchese merchant in Bruges, and his bride solemnize their marriage vows before two witnesses (one of whom is probably the artist himself), just visible in the convex mirror on the back wall. The Latin inscription above reads, in translation, 'Jan van Eyck was here. 1434'. The symbols in the picture – for example, the dog representing marital fidelity, and the single burning candle for the all-seeing Christ, as well as such obvious signs of piety as the rosary on the wall and the scenes from Christ's passion in the carved mirror frame – emphasize that this is not simply a portrait, but also a testimony of a solemn and sacred event.

**Plate 5.** PETRUS CHRISTUS (d. 1472/3): *St Eligius and the Lovers.* 1449. Panel, 100 × 85 cm. New York, Metropolitan Museum of Art, Robert Lehman Collection.
St Eligius, patron saint of gold and silversmiths, is shown at his trade, weighing a ring for a betrothed couple. The meticulous detailing of the objects in the shop and the studied play of light derive from Jan van Eyck, whom Christus succeeded as leading painter in Bruges. A more obvious connection is the round convex mirror, presumably a quotation from the *Arnolfini Marriage* (Plate 4). The organization of space and the gestures of the figures, however, have a gaucheness not to be found in the older master's works.

**Plate 6.** JAN (and HUBERT?) VAN EYCK: *The Ghent Altarpiece.* (Central panels). Completed 1432. Panel, 349 × 243 cm. Ghent, Cathedral of St Bavo.
These are the central panels of a twelve-foot high, winged altarpiece, painted for the chapel where it still stands. Above, God the Father is enthroned between the Virgin and St John the Baptist. Below, figures on a much humbler scale (including prophets, apostles, martyrs and virgins) converge to worship the Holy Lamb – a symbol of Christ in his sacrificial role. The palm trees in the exotic landscape, which continues through the lower panels of the wings (not illustrated), may relate to Jan van Eyck's travels. As confidential agent for Philip the Good, Duke of Burgundy, his many secret journeys took him as far as Portugal and perhaps Spain. There is controversy over the existence of Jan's elder brother Hubert. He is mentioned as the initiator of this altarpiece in an inscription on the outer frame, but the authenticity of this inscription has been disputed

**Plate 7.** ROGIER VAN DER WEYDEN (1399/1400–64): *The Descent from the Cross.* About 1435. Panel, 220 × 262 cm. Madrid, Prado.
This picture is usually considered to be the artist's masterpiece, and although only this central panel of the original triptych remains, it is sufficient to show the unique power of his imagery. To create an illusion of reality, the grief-stricken figures have been painted almost life-size. Their position in a stone niche, with illusionistic tracery at the corners, would have seemed more convincing than the customary landscape background when the painting hung in its original setting – the church of Notre-Dame-hors-les-Murs in Louvain.

**Plate 8.** JAN VAN EYCK: *The Virgin and Child with Chancellor Rolin.* About 1434? Panel, 66 × 62 cm. Paris, Louvre.
Nicolas Rolin, unscrupulous chancellor of Burgundy, presented this painting to Autun Cathedral. To find a donor in the company of the Virgin without the sponsorship of mediating saints is rare at this date, and the significance of this treatment would not have been lost on Rolin's contemporaries. The location is an elevated throne-room, largely in a Romanesque style, with rich marble columns and lively carvings (showing scenes of sin from Genesis). Outside, beyond an enclosed garden with its clusters of lilies and roses and

its strutting peacocks, there is a prospect of one of the freshest landscapes of this period, with a shining river winding through a contemporary city to the distant hills.

**Plate 9.** ROGIER VAN DER WEYDEN: *The Virgin and Child with Saints Peter, John the Baptist, Cosmas and Damian.* About 1450? Panel, 53 × 38 cm. Frankfurt, Städelsches Kunstinstitut.

Bartolommeo Fazio, writing in 1456, refers to 'Roger of Gaul's' admiration for certain frescoes that he saw in Rome. It is not known what other cities Rogier visited on his Italian journey of 1450, or which of his paintings were produced on these travels. This work shows some Italian features in the symmetry of the composition and in the arrangement of the figures in the manner of a *sacra conversazione*. The two saints on the right, Cosmas and Damian, were patron saints of the Medici family; and this, together with the fact that the red fleur-de-lys was the emblem both of the Medici family and of the city of Florence, points rather inconclusively to a possible Florentine visit by the artist.

**Plate 10.** JAN VAN EYCK: *St Barbara.* 1437. Panel, 34 × 18 cm. Antwerp Musée Royal des Beaux-Arts.

This tiny monochrome brush drawing has a contemporary simulated marble frame (not illustrated) bearing the words 'IOHES DE EYCK ME FECIT. 1437'. This, together with the fine detailing, has been taken by some to indicate that the artist considered the work to be a finished picture. It seems more likely, however, that it is an underdrawing, the frame being constructed before the picture was painted, as was then customary. St Barbara sits before the tower in which she is to be incarcerated, holding her martyr's palm, while in the background the workmen busy about their labours and the overseer (right) has an altercation with his foreman on the top of the tower.

**Plate 11.** ROGIER VAN DER WEYDEN. *Portrait of a Lady.* About 1450–60. Panel, 36 × 27 cm. London, National Gallery.

The sitter is unknown, but the head-dress suggests a date of about 1450–60. On the reverse there is a *Christ Crowned with Thorns* of inferior quality. The sensitive delineation of the pious lady's features makes this one of the artist's finest portraits.

**Plate 12.** HANS MEMLINC (c. 1430/40–1494): *Man Holding a Medal.* 1470. Panel, 26 × 20 cm. Antwerp, Musée Royal des Beaux-Arts.

In his day, Memlinc was a highly successful and prolific artist, producing both religious works and portraits. The former tend to be skilled syntheses of what had been done before, but in the latter he introduces a new type. The traditional three-quarter-view bust is set against a luscious open landscape, which provides a vivid contrast to the darkly dressed foreground figure. This portrait type seems to have been particularly popular with Italian clients, and this unknown man was probably one of these. The coin, which shows the Emperor Nero, is more likely to indicate that the sitter was a collector than that he was a maker of medals.

**Plate 13.** ROGIER VAN DER WEYDEN: *Philippe de Croy.* Not later than 1460–1. Panel, 49 × 30 cm. Antwerp, Musée Royal des Beaux-Arts.

This portrait shows the artist's skill at depicting the tastes and character of his sitter – in this case a pious, cultured courtier in the entourage of Philip the Good and Charles the Bold. It is one of a group of devotional diptychs executed towards the year 1460, in which the praying donor faces a panel showing the Virgin and Child. Unfortunately, in this case as in most of the others, the two panels have been separated; the one belonging to this work is now in California. In contrast to the gold background behind the Virgin and Child, the earthly sitter has a sombre setting and dark clothing, to draw attention to his sensitive, elegant face and hands as he holds his rosary in silent contemplation.

**Plate 14.** HUGO VAN DER GOES (active 1467, d. 1482): *The Adoration of the Shepherds.* (Central panel of the *Portinari Altarpiece.*) About 1475. Panel, 252 × 304 cm. Florence, Uffizi.

This famous altarpiece, commissioned by Tommaso Portinari, a Medici agent in Bruges,

was transported to Florence around 1475. Flemish paintings of this size and quality were rare in Italy, and it aroused considerable interest, partly because of its curiously high viewpoint and variations in scale, partly because of the strong characterization of the shepherds and the lifelike portraits of the Portinari family on the wings, but above all for the skilled handling of the oil painting technique and the meticulous attention to detail. The foreground 'still-life' brings an element of foreboding to the scene. The red lily symbolizes the blood of the Passion, for example, and the wheat the bread of the Eucharist. These hint at the religious melancholia which was soon to cause the artist's death.

**Plate 15.** GERARD DAVID (d. 1523): *The Annunciation*. Panel, 41 × 32 cm. Frankfurt, Städelschcs Kunstitut.

The Virgin, interrupted at prayer, listens submissively to the angel Gabriel's message. Her sad expression, and the extensive use of black fabrics, indicate her foreknowledge of the tragic events which are to follow. The artist's interest is in showing the full implications of a sacred event, and he reduces the incidental details to make this meaning as clear as possible.

**Plate 16.** HUGO VAN DER GOES: *The Fall of Man*. About 1470. Panel, 33 × 23 cm. Vienna, Kunsthistorisches Museum.

Eve, listening to the semi-human serpent, plucks fruit from the tree of knowledge to give to Adam. This luxuriant Garden of Eden forms the left half of a diptych, and the strongly diagonal design, created by Eve's gesture, is balanced when the two panels are seen together. However, it is not just the compositions that are complementary; their subjects are also. Stories in the Old Testament were believed to foreshadow events in the life of Christ. The other panel of this diptych shows a Lamentation – the death of Christ being the consequence of the Fall of Man.

**Plate 17.** GEERTGEN TOT SINT JANS (active late fifteenth century): *St John the Baptist in the Wilderness*. 1480s? Panel, 42 × 28 cm. Berlin-Dahlem, Staatliche Museen.

It is thought that this tiny picture was painted at the monastery of the Order of St John in Haarlem, where the artist was a lay brother until his death at about the age of 28. It is too small to have been an altarpiece and may have hung in a monk's cell. The melancholic figure of St John is seated in a luxuriant wilderness, richly populated with animals and birds. Perhaps the most remarkable feature of this picture is the handling of the recession of the landscape. No Netherlandish artist before Geertgen shows such confidence in the representation of continuous space.

**Plates 18 and 19.** HIERONYMUS BOSCH (living 1475, d. 1516): *The Garden of Earthly Delights*. (Central panel and right wing). About 1505. Panel, 220 × 195 cm. (including left wing). Madrid, Prado.

Although Bosch was esteemed in his lifetime, little is now known of this native of North Brabant. Many attempts have been made to explain his bizarre imagery, including Freudian interpretations, analogies with the Surrealists, and suggestions of heresy. In the sixteenth century, however, his works were accepted as expressions of orthodox Catholicism, not least of all by that avid defender of the faith, Philip II of Spain, who owned the paintings reproduced here. This triptych is the most complex of his paintings. It views man's sinfulness on a cosmic scale. The outside of the altarpiece shows the newly created world; the left wing, the Garden of Eden; the centre, man abusing God's creation after the Fall, and the right, the consequence of his folly – Hell. The upper part of the central panel reads like a burlesque of Van Eyck's *Adoration of the Mystic Lamb* (Plate 6). Throughout, there is much play on the devouring of fruits – reminiscent of the Fall, and more generally symbolic of sensuality. In Hell, all is changed. Musical instruments, the accompaniment of pleasure, now become devices of torture; the obedient beasts of the Garden have become the devourers. The upper regions, with the crowds of lost souls and beams of baleful light, recall Dante's vision of the Inferno.

**Plate 20.** HIERONYMUS BOSCH: *The Haywain*. (Central panel of a triptych). About 1500. Panel, 135 × 100 cm. Madrid, Prado.

This painting also deals with human folly, traceable in this case to the proverb of the wagon of hay as a 'wagon of nought' from which each takes what he can. The whole world chases material gain, even monks – two of whom are assaulting a woman beneath the cart's wheels. Enthroned on the hay is an image of carnal love. An earthly troubadour is abetted by the raucous notes of a demon playing his nose, and an angel looks up in despair to the vision of Christ in the clouds, which no mortal notices. This picture is considered to be earlier than the *Garden of Earthly Delights* (Plates 18 and 19). In technique it is closer to early Netherlandish paintings.

**Plate 21.** Ascribed to JOACHIM PATENIR (active 1515, d. *c.* 1524): *St Jerome in a Rocky Landscape*. Panel, 36 × 34 cm. London, National Gallery.

St Jerome and his lion are in the foreground. Further back is depicted one of the lion's exploits, the story of the merchants and the ass, mentioned in the medieval collection of lives of saints, the *Golden Legend*. This fantastic rocky scene, with its panoramic vista and tiny figures, is typical of the pictures for which Patenir was famed. It is, in fact, close in composition to works known to be by him, and is of sufficient quality to be ascribed with some measure of confidence to his hand.

**Plate 22.** QUENTIN MASSYS (1464/5–1530): *Portrait of a Man*. Panel, 80 × 64.5 cm. Edinburgh, National Gallery of Scotland.

Massys was the finest painter in Antwerp in the early sixteenth century. Nowadays he is most admired for his portraits, in which traditional Flemish motifs are reinterpreted in the light of recent developments in Italian art. In this work the half-length figure, set against a landscape reminiscent of Memlinc (Plate 12), is given an Italianate grace and breadth. The soft modelling and the spacious loggia suggest a knowledge of Leonardo da Vinci's work. Unfortunately, the identity of this sitter is not known. Presumably he was, like Massys's famous patron, Erasmus, a devout scholar with humanist leanings. The religious attributes may be an allusion to the sitter's patron saint.

**Plate 23.** JOOS VAN CLEVE (active 1511, d. 1540/1): *Margaretha Boghe*. About 1530. Panel, 57.1 × 39.6 cm. Washington, National Gallery of Art.

One of a pair of portraits commemorating the engagement of Margaretha Boghe to Joris W. Vezeler. She holds a pink, symbol of betrothal, and toys meditatively with a rosary.

**Plate 24.** PIETER AERTSEN (1508/9–1575): *The Egg Dance*. 1557. Panel, 84 × 172 cm. Amsterdam, Rijksmuseum.

The egg dance, an ancient custom with many variations, was popular in the northern Netherlands in the sixteenth and seventeenth centuries. The idea was to work the eggs out of a circle of chalk, flowers, leaves and other objects. A basket of eggs was the usual prize. Aertsen, who had been a master in Antwerp in 1535, had settled in Amsterdam for good by the time this picture was painted. He was one of the pioneers of genre painting, which was to become so important in Holland in the seventeenth century.

**Plates 25 and 27.** PIETER BRUEGEL THE ELDER (active 1551, d. 1569): *The Peasant Dance*. About 1567–8. Panel, 114 × 164 cm. Vienna, Kunsthistorisches Museum.

Like Aertsen's *Egg Dance* (Plate 24), this painting records a peasant pastime. Yet while Aertsen went to great lengths to show his skill in handling still-life details and unusual perspectives, Bruegel concentrates on acute observation of character. One feels he must have had a greater sympathy for the simple folk enjoying themselves, but this may not be the case. His near contemporary, Carel van Mander, spoke of Bruegel representing peasants 'naturally, as they really were, betraying their boorishness in the way they walked, danced, stood still, or moved'. His erudite patrons could have read such 'boorish' scenes as warnings against brutish behaviour. Here the cheap print of the Virgin on the tree shows that the village is celebrating a holy day. Yet the religious meaning has been

lost. The church in the background is neglected, and the flowers to the Virgin are about to topple from the vase. Instead, the populace give themselves over to a vulgar dance before the inn on the left, while graver profanities – drunkenness and licentiousness – devolve from it. Even innocence is being corrupted, for the two children by the table are about to join the dance.

**Plate 26.** FRANS FLORIS (*c.* 1517–70): *Portrait of an Elderly Woman.* 1558. Caen, Musée des Beaux-Arts.

Floris belonged to an eclectic generation of artists who visited Italy and assimilated the achievements of the High Renaissance and Mannerism. This is reflected both in history painting and in portraits such as this one. The three-quarter-length pose, which makes the sitter seem very close to the spectator, and the inclusion of the dog show an awareness of contemporary Venetian portraiture.

**Plate 28.** PIETER BRUEGEL THE ELDER: *Dulle Griet* (Mad Meg). 1562. Panel, 115 × 161 cm. Antwerp, Museum Mayer van den Bergh.

In his lifetime, Bruegel was hailed as a second Bosch. He certainly admired the work of his predecessor, and emulated his bizarre imagery in the engravings he designed for the popular market. He resorted less often to such extremes in his paintings, which were executed for more refined patrons. *Dulle Griet* is an exception. It shows the legendary hag whose greed was such that she braved even the fires of Hell to gather booty – and emerged successful! This painting emphasizes another side of Bruegel's contemporary reputation: his drollery. Unlike Bosch's inventions, these grotesque chimeras – bottom-heads and the like – are figures of fun. Even the fearsome mouth of Hell has become a gaping fool, peeping from behind a tree at the looter who has outdone his own voraciousness.

**Plate 29.** PIETER BRUEGEL THE ELDER: *The Fight between Carnival and Lent.* 1559. Panel, 118 × 164.5 cm. Vienna, Kunsthistorisches Museum.

Painted at the time when Bruegel was entering his mature period, this picture combines the panoramic vision evident in the landscapes he painted after his visit to Italy (1552–3) with the multitudinous folk imagery of the designs he had recently been producing for the publisher Hieronymus Cocke. The allegorical conflict between gluttonous Carnival, astride a barrel, and the shrivelled, hag-like Lent, on a trolley, becomes the starting-point for a broad cross-section of activities. On the left are masques and feasting; on the right, sobriety and good works; while in between a baker displays fare for both sides.

**Plate 30.** PIETER BRUEGEL THE ELDER: *The Tower of Babel.* 1563. Panel, 114 × 155 cm. Vienna, Kunsthistorisches Museum.

The story in Genesis describes how the survivors of the Flood built a tower 'whose top may reach unto heaven', and how God prevented the completion of this act of impiety by 'confounding their language, that they may not understand one another's speech'. The unfinished tower dominates the picture. Its massiveness is emphasized by the tiny figures at work on it, and the minutely described city below. The artist has followed other sixteenth-century representations of the tower, showing it as a stepped structure. It is also inspired by the greatest antique building that Bruegel knew at first hand – the Colosseum in Rome.

**Plate 31.** PIETER BRUEGEL THE ELDER: *Hunters in the Snow.* 1565. Panel, 117 × 162 cm. Vienna, Kunsthistorisches Museum.

One of a series representing the 'Twelve Months', painted for the connoisseur Niclaes Jonghelinck. Only five of these have survived, and it may be that there were never more than six. Indeed, this scene includes activities traditionally used to describe both of the mid-winter months – the singeing of a pig for December, and the return from the hunt for January. The painting is a supreme example of the artist's powers as a landscapist. The carefully spaced foreground trees and the soaring magpie prelude a vista of snow and ice. Here Bruegel explores both familiar scenes such as peasants skating, and exotic features like the rocky outcrops seen during his journey through the Alps. But it is the hunched

silhouettes of the huntsmen, their colours darkened by contrast with the snow, that make this one of the most alluring evocations of winter ever painted.

**Plate 32.** GILLIS VAN CONINXLOO (1544–1607): *Landscape with Elijah*. Canvas, 115 × 178 cm. Brussels, Musées Royaux des Beaux-Arts.

A Protestant refugee from Antwerp, Coninxloo travelled in France and Germany before settling in Amsterdam in 1595. He was one of the finest and most influential landscape painters of his day, and he specialized in forest scenes. These, although full of realistic details, appear wild and fantastic, and any figures are usually relatively small in scale. In this painting, two episodes from the story of Elijah are shown. In the foreground he waits beside the brook Cherith during a drought, and is brought bread and meat by ravens, while in the middle distance we see the tiny figures of Elijah and the widow woman, whose son he restores to life.

**Plate 33.** JAN BRUEGHEL THE ELDER (1568–1625): *The Burning of Troy*. Copper, 26 × 35.4 cm. Munich, Alte Pinakothek.

Aeneas carries his father Anchises from Troy, as the city is set on fire by the victorious Greeks. With him also are his wife (who is later lost in the darkness) and son, who carry with them their precious household gods. The city of Troy bears a strong resemblance to Rome, which the artist visited around 1592–4, and the poses and gestures of the figures derive from Italian High Renaissance paintings which he would have seen there.

**Plate 34.** SIR PETER PAUL RUBENS (1577–1640): *Rubens and his Wife, Isabella, in the Honeysuckle Arbour*. 1609–10. Canvas, 174 × 132 cm. Munich, Alte Pinakothek.

A celebration of the artist's marriage to the seventeen-year-old Isabella Brant in 1609. In contrast to the great marriage painting of his forerunner Van Eyck (Plate 4), the dominant note in this picture is one of tender affection, emphasized by the setting in a bower of honeysuckle. But it shares with the Arnolfini portrait a sense of success and well-being. Much care has been taken to give a detailed record of the couple's finery. There is also a rhythmic harmony linking the two figures, a feature that was to remain the basis of Rubens's manner when he later developed a more spirited technique.

**Plate 35.** SIR PETER PAUL RUBENS: *Hélène Fourment in her Wedding Dress*. 1630–2. Panel, 162 × 134 cm. Munich, Alte Pinakothek.

In 1630, after four years as a widower, Rubens married Hélène Fourment, the sixteen-year-old daughter of a wealthy silk merchant, and a relative of his favourite model, Suzanne Fourment. It is significant that Rubens, though now ennobled, still chose to marry a bourgeois girl – 'one who would not blush to see me take my brush in my hand'. While the young bride is richly attired and seated in the stately loggia, such a familiar feature in court portraiture, she is not made to affect the airs of a great lady. Instead, Rubens brings out her timid expectancy, for example, in the way that she has been tilted out of true with her surround to peer up at us.

**Plate 36.** SIR PETER PAUL RUBENS: *The Descent from the Cross*. About 1611. Panel, 114 × 76 cm. London, Courtauld Institute Galleries.

A highly finished study, possibly the contract sketch, for the central panel of the large altarpiece in Antwerp Cathedral, which Rubens delivered in September 1612. The refurbishing of churches was an important part of the programme for restoring public morale in Flanders after the civil war. As a devout Catholic, Rubens played his part with evident relief. Emulating the great Venetian masters, as well as those Roman masters who had been his rivals while in Italy, he has displayed superlative skill in handling a composition of falling diagonals. This virtuoso device focuses attention on the slumped figure of the dead Christ.

**Plate 37.** SIR PETER PAUL RUBENS: *The Rape of the Daughters of Leucippus*. About 1618. Canvas, 222 × 209 cm. Munich, Alte Pinakothek.

An erudite classical scholar, Rubens delighted in presenting the myths of antiquity in a vivid manner. This picture shows the abduction of two royal sisters by Castor and Pollux,

the twin sons of Zeus. Although the scene is a violent one, the ingeniously interlocking pairs of figures harmonize to make one more aware of liberated energy than of distress. The composition of this nearly square canvas is based on the centre of Leonardo's *Battle of Anghiari* cartoon. Typically, Rubens has transformed a moment of conflict into a scene of frank erotic display.

**Plate 38.** SIR PETER PAUL RUBENS: *The Reception of Marie de' Medici at Marseilles.* 1622–5. Canvas, 394 × 295 cm. Paris, Louvre.

This painting is one of a cycle of twenty-one pictures of scenes from the life of the French Queen Mother, Marie de' Medici, commissioned by her for a gallery in the new Luxembourg Palace. It shows her as a young bride on her way to meet her husband, Henry IV, in 1600. She is greeted by France, in a blue robe, while Fame in the air above and the spirits in the sea fanfare her arrival. As with all his major cycles, Rubens relied heavily on assistants in the execution of his designs, and he was able to promise to deliver the whole series in two years. This particular picture is usually held to be the one with the most of Rubens's own handiwork in it.

**Plate 39.** JACOB JORDAENS (1593–1678): *Pan and Syrinx.* About 1625. Canvas, 173 × 136 cm. Brussels, Musées Royaux des Beaux-Arts.

Beside the banks of the river Ladon, the nymph Syrinx is transformed into a clump of reeds to escape the amorous advances of her pursuer, Pan. In the background a cupid symbolically extinguishes the torch of love. The full-bodied figures, the vigour and drama of Jordaens's style, derive from Rubens, in whose studio he worked for many years, but he fails to capture Rubens's lightness and subtlety of brushwork or delicacy of narrative.

**Plate 40.** SIR ANTHONY VAN DYCK (1599–1641): *Frans Snyders.* About 1620. Canvas, 142 × 105 cm. New York, Frick Collection.

Frans Snyders was a painter of animals and still-life, both in his own right and in collaboration with Rubens, whom he sometimes assisted with his hunting scenes and other subjects. He was also a friend of another of Rubens's assistants, Van Dyck, who painted this casually elegant portrait of Snyders (and a pendant of his wife) in Antwerp in about 1620. Van Dyck's style is here closer to that of Rubens than it is in the works he later painted for the English court.

**Plate 41.** SIR ANTHONY VAN DYCK: *Lady Shirley.* 1622. Canvas, 200.7 × 133.4 cm. Sussex, Petworth House, The National Trust.

The subject of this portrait is the Circassian wife of Sir Robert Shirley, who was at that time Persian ambassador in Rome. There are studies for the pendant portrait of Sir Robert (now also at Petworth) in Van Dyck's Italian sketch book of 1622. The rich colour shows the strong influence of Venetian art on the painter's style at this time. The exotic background is presumably intended to suggest the sitter's romantic origins.

**Plate 42.** SIR PETER PAUL RUBENS: *Landscape with the Château of Steen.* About 1636. Panel, 131 × 229 cm. London, National Gallery.

This is a view of the country residence near Malines that Rubens bought in 1635. It shows an early morning in autumn; the laden cart is setting off for market, a sportsman is after game, and the hedgerows are full of late-flowering plants. The seventeen divisions in the picture's wooden support suggest that the composition grew as it was painted, fanning out from the wooded château to the expansive view on the right. Its asymmetry may be due to its having had a pendant – possibly the *Landscape with a Rainbow* (London, Wallace Collection). Even on its own, however, it is marvellously complete and vibrant. It is small wonder that this celebration of idyllic rural husbandry should have appealed so much to Constable when he saw it in 1803.

**Plate 43.** DAVID TENIERS THE YOUNGER (1610–90): *Archduke Leopold-Wilhelm's Gallery.* 1651. Canvas, 127 × 162.6 cm. Sussex, Petworth House, The National Trust.

The great collector, Archduke Leopold-Wilhelm, Regent of the Netherlands, employed

David Teniers the Younger as court painter and keeper of his pictures. The artist made numerous copies of these, and two hundred and forty-four of them were engraved in 1660 with the title *Theatrum Pictorium*. He also painted several pictures of the Archduke's gallery.

**Plate 44.** ADRIAEN BROUWER (1606?–30): *Tavern Scene*. About 1630. Panel, 47.9 × 75.9 cm. London, National Gallery (on loan from a private collection). This short-lived artist spent the early part of his career in Holland, and his works had considerable influence on the development of genre painting there; yet his subjects and technique have a liveliness and vigour more Flemish than Dutch. He was born in Flanders and returned there, to Antwerp, for the last few years of his life. Initially, his source of inspiration seems to have been the peasant subjects of Pieter Bruegel the Elder, but his view of the life of the common man is even more coarse and earthy than Bruegel's. They carouse, drink, eat, smoke and brawl in squalid interiors like the one illustrated here.

**Plate 45.** CORNELIS DE VOS (1584–1651): *Family Group*. 1631. Canvas, 178 × 234 cm. Antwerp, Musée Royal des Beaux-Arts.
The head of the family is seated amongst his male offspring, his heir at his left hand, while the mother and daughter form a pair on their own. Yet by skilled positioning and gesture, the artist has compositionally linked the two parts of the painting. Although group portraiture was known in the sixteenth century, it was only during the seventeenth century that its problems and possibilities were fully explored. In this work the informal arrangement has added extra vitality to the family group.

**Plate 46.** JAN BRUEGHEL THE ELDER: *Large Bouquet of Flowers in a Tub*. About 1610? Panel, 124.5 × 96.2 cm. Munich, Alte Pinakothek.
Flower painting became a popular genre in both Flanders and Holland in the seventeenth century. Such pictures were often executed over a period of many months and could thus include flowers from different seasons. Rare and exotic plants were often introduced for their value, others for their literary or religious meaning. In some cases the picture merely served to display the painter's virtuosity. Jan, nicknamed 'Velvet' Brueghel, was particularly admired for the meticulous execution of his still-lifes, and sometimes he collaborated on Rubens's pictures when detailed plants and animals were required.

**Plate 47.** DANIEL SEGHERS (1590–1661) AND FRANS (?) DENYS (active 1650): *Garland of Flowers with the Holy Family*. About 1650? Canvas, 128 × 97 cm. Antwerp, Musée Royal des Beaux-Arts.
An example of a type of picture combining religious subjects and flower painting for which Rubens and Jan Brueghel the Elder had set a precedent some thirty years earlier with their *Madonna and Child in a Garland of Flowers* (Paris, Louvre).

**Plate 48.** SIR ANTHONY VAN DYCK: *Equestrian Portrait of Charles I*. Late 1630s? Canvas, 367 × 292 cm. London, National Gallery.
This is one of the grandest of the representations of this English monarch that Van Dyck produced after being appointed court painter in 1632. According to the Italian theorist Bellori, the picture is in imitation of Titian's *Equestrian Portrait of the Emperor Charles V* (now in the Prado, Madrid), which Charles I would have seen in Spain. From the time of the Renaissance, it had become customary for monarchs to have themselves represented on horseback in the manner of Roman statues of emperors and generals. Neither painter nor subject could have known that in a few years the king would be adopting this pose in earnest, when he fought the civil war that was to lead to the end of his reign and to his execution.

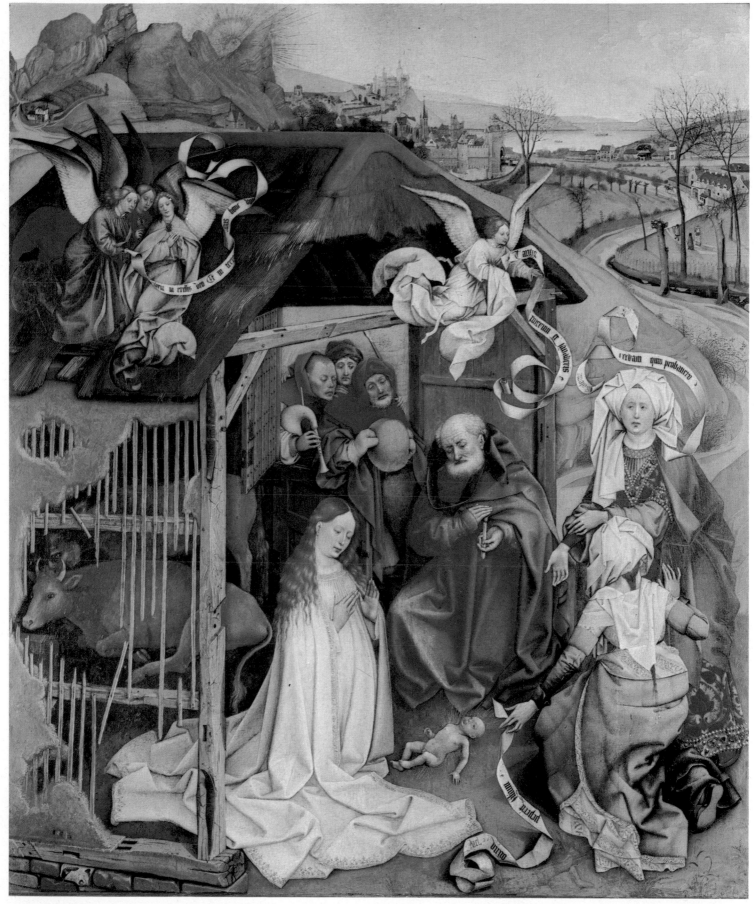

1. ROBERT CAMPIN, 'MASTER OF FLÉMALLE' (1378/9–1444): *The Nativity*. About 1430? Dijon, Musée des Beaux-Arts

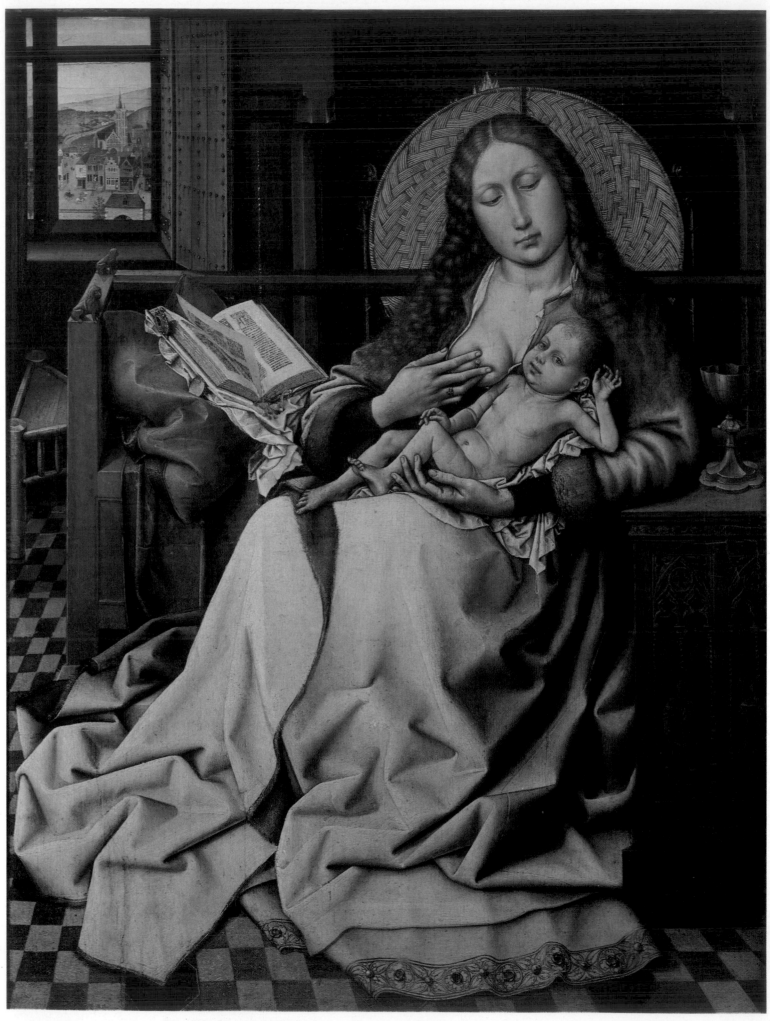

2. ROBERT CAMPIN: *The Virgin and Child before a Firescreen*. Before 1430. London, National Gallery

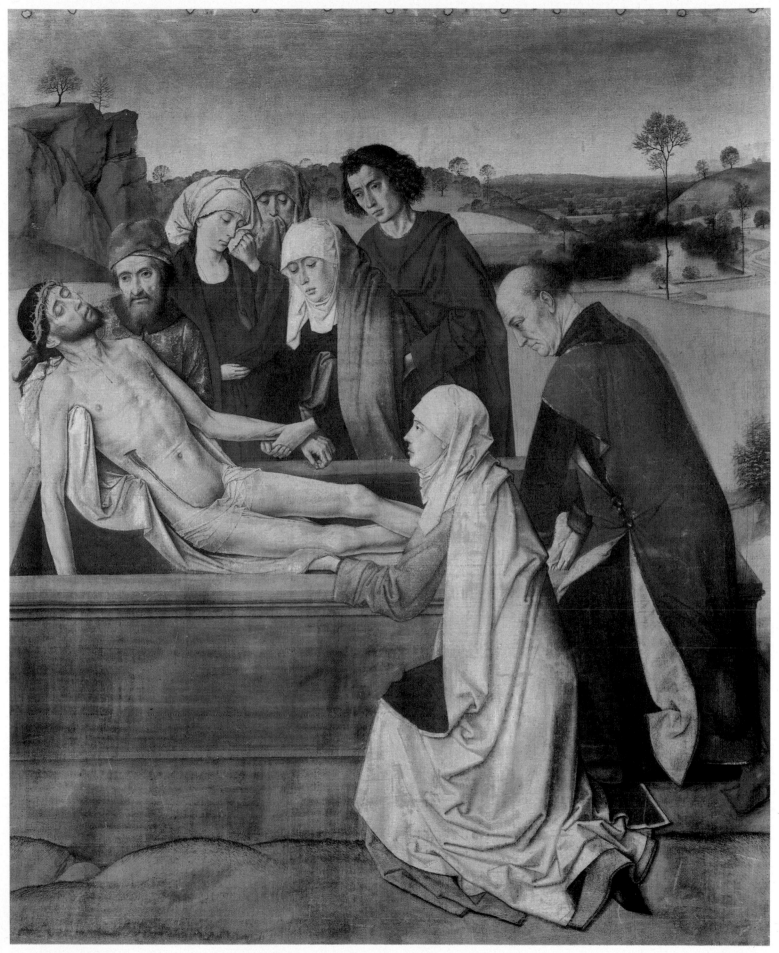

3. DIERIC BOUTS (d. 1475): *The Entombment*. About 1455? London, National Gallery

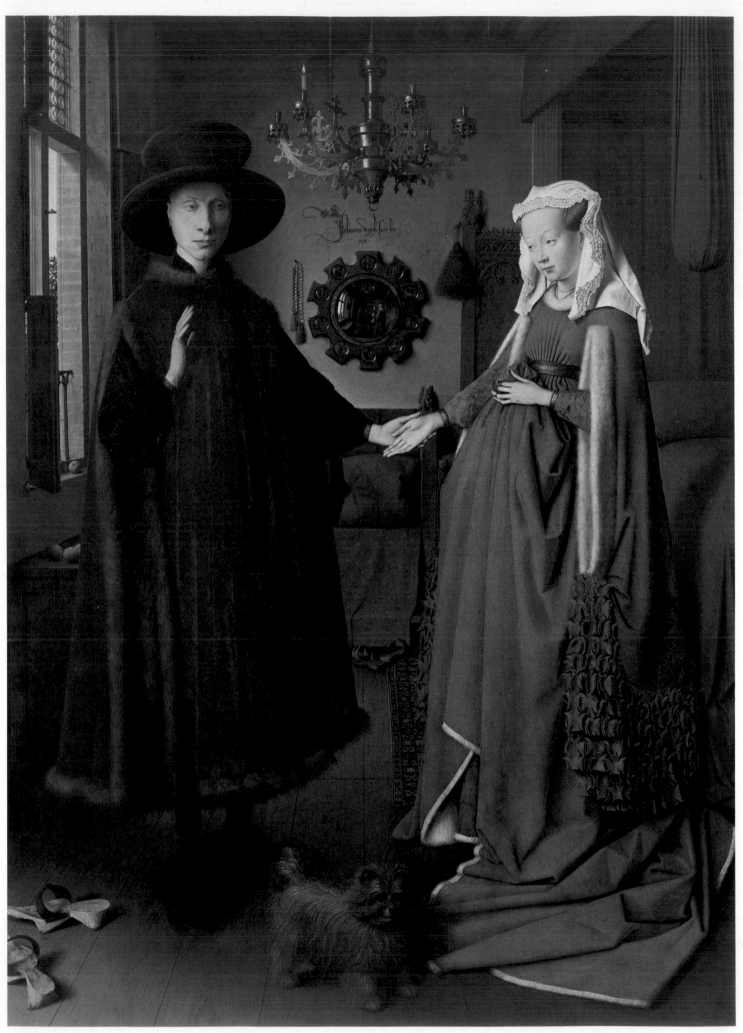

4. JAN VAN EYCK (d. 1441): *The Marriage of Giovanni Arnolfini and Giovanna Cenami.* 1434. London, National Gallery

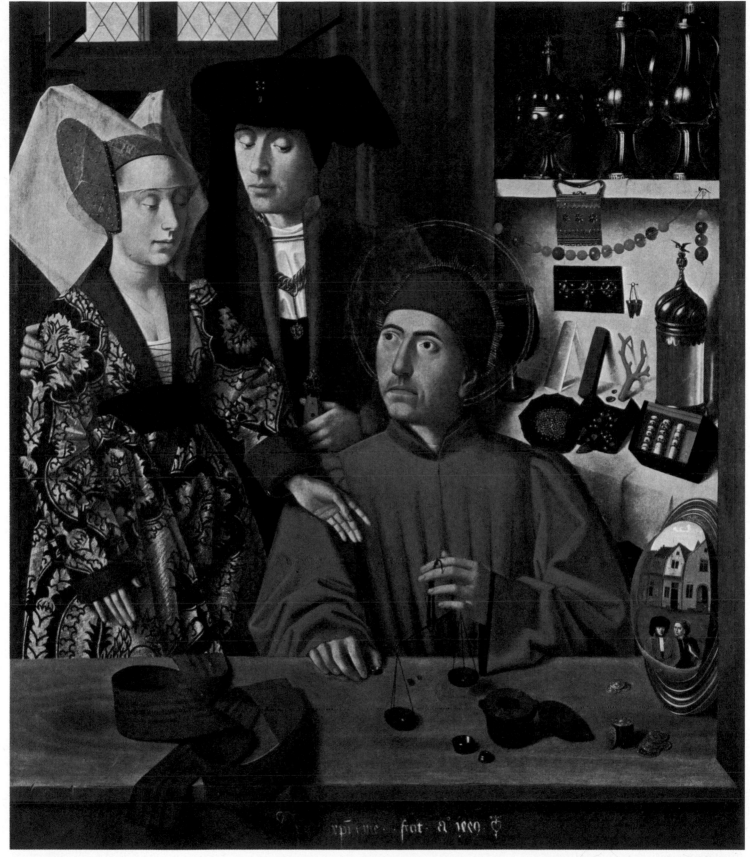

5. PETRUS CHRISTUS (d. 1472/3): *St Eligius and the Lovers*. 1449. New York, Metropolitan Museum of Art, Robert Lehman Collection

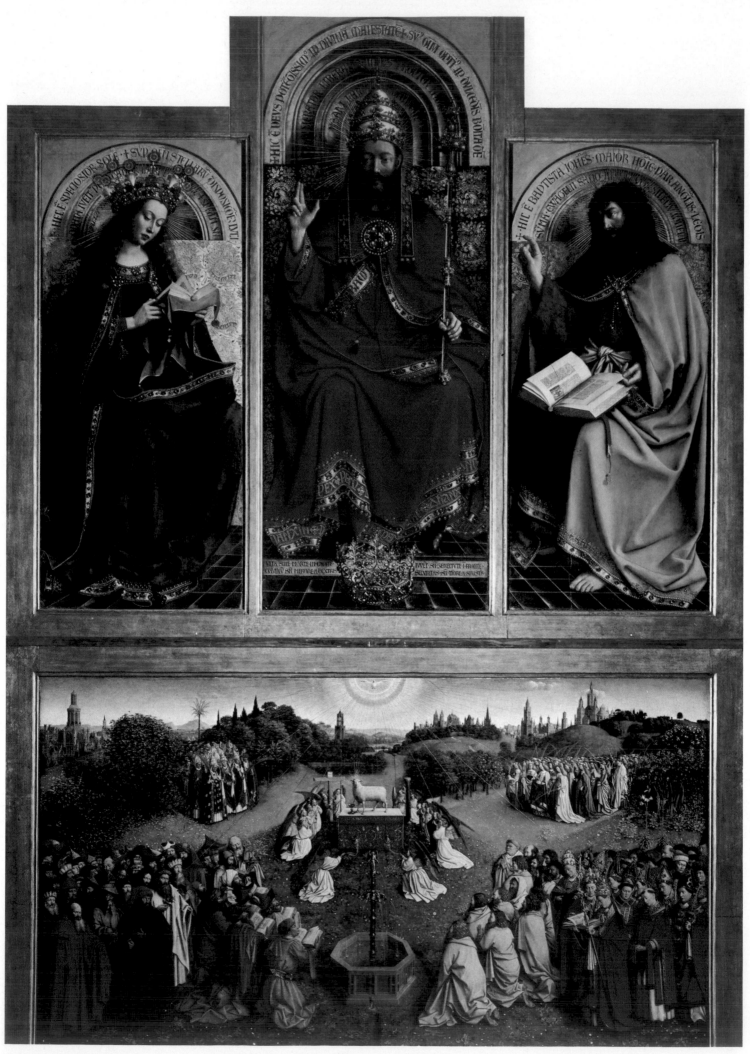

6. JAN (and HUBERT?) VAN EYCK: *The Ghent Altarpiece* (central panels). Completed 1432. Ghent, Cathedral of St Bavo

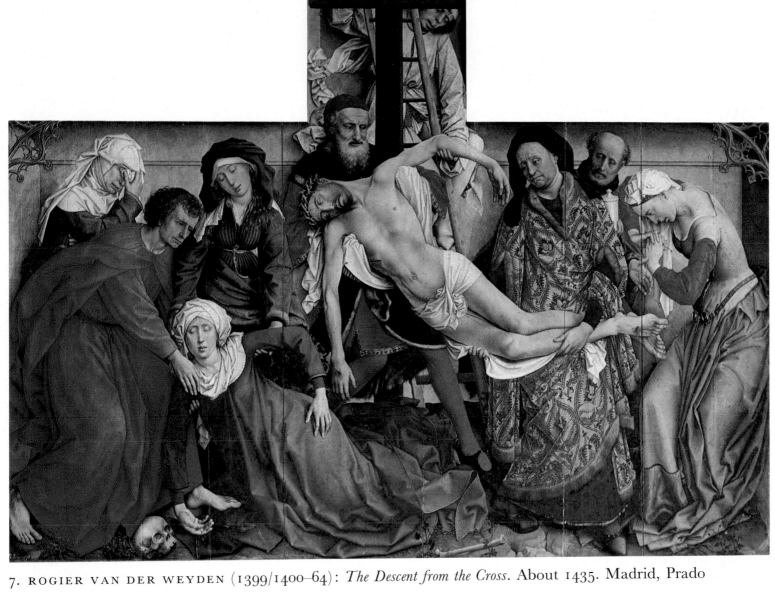

7. ROGIER VAN DER WEYDEN (1399/1400–64): *The Descent from the Cross*. About 1435. Madrid, Prado

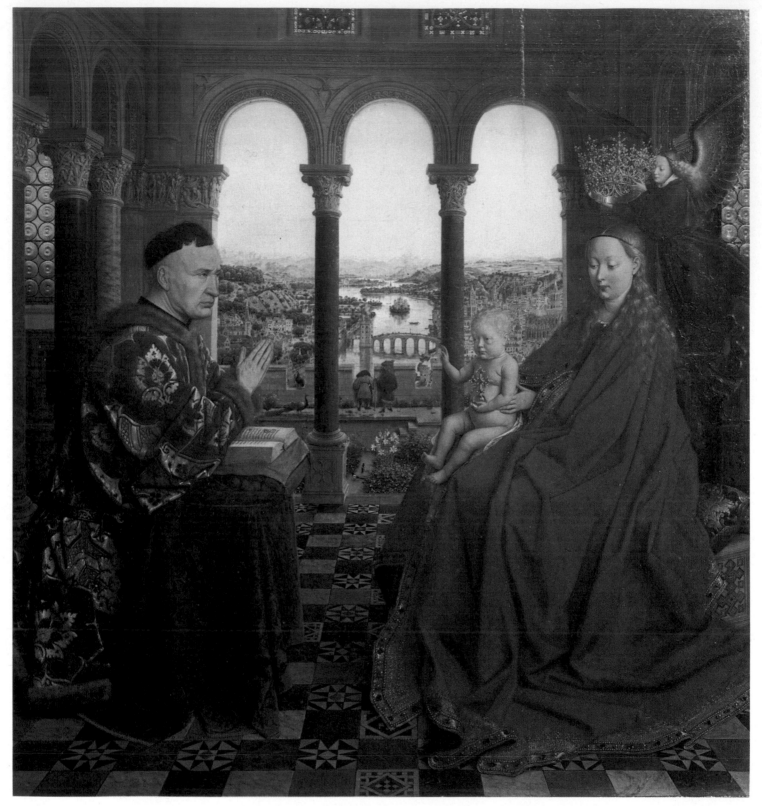

8. JAN VAN EYCK: *The Virgin and Child with Chancellor Rolin*. About 1434? Paris, Louvre

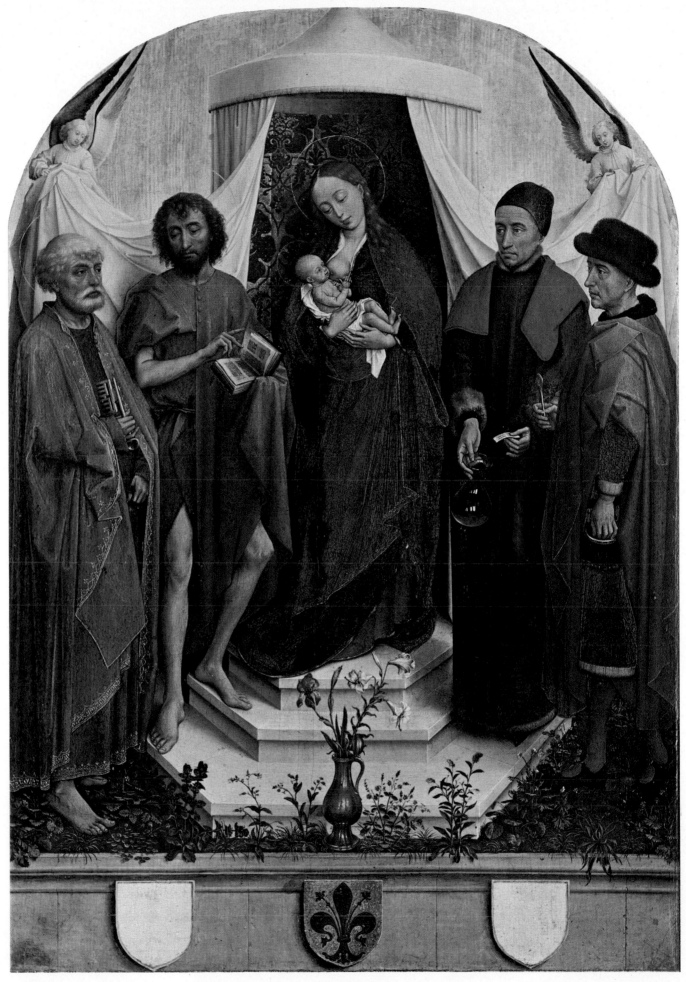

9. ROGIER VAN DER WEYDEN. *The Virgin and Child with Saints Peter, John the Baptist, Cosmas and Damian.* About 1450? Frankfurt, Städelsches Kunstinstitut

86717

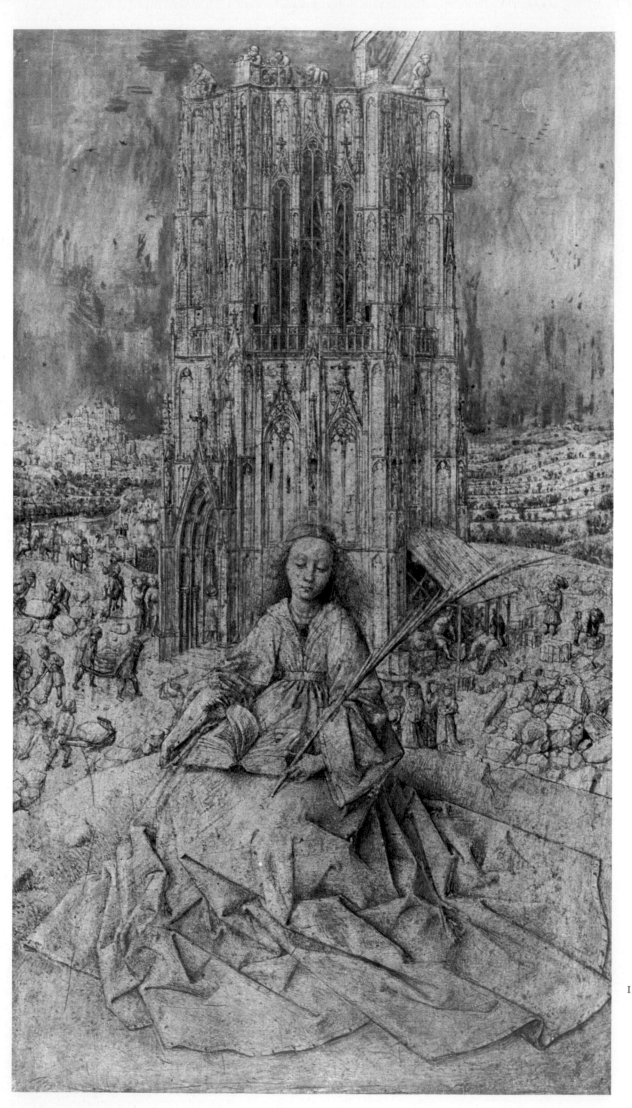

10. JAN VAN
EYCK:
*St Barbara.*
1437. Antwerp,
Musée Royal des
Beaux-Arts

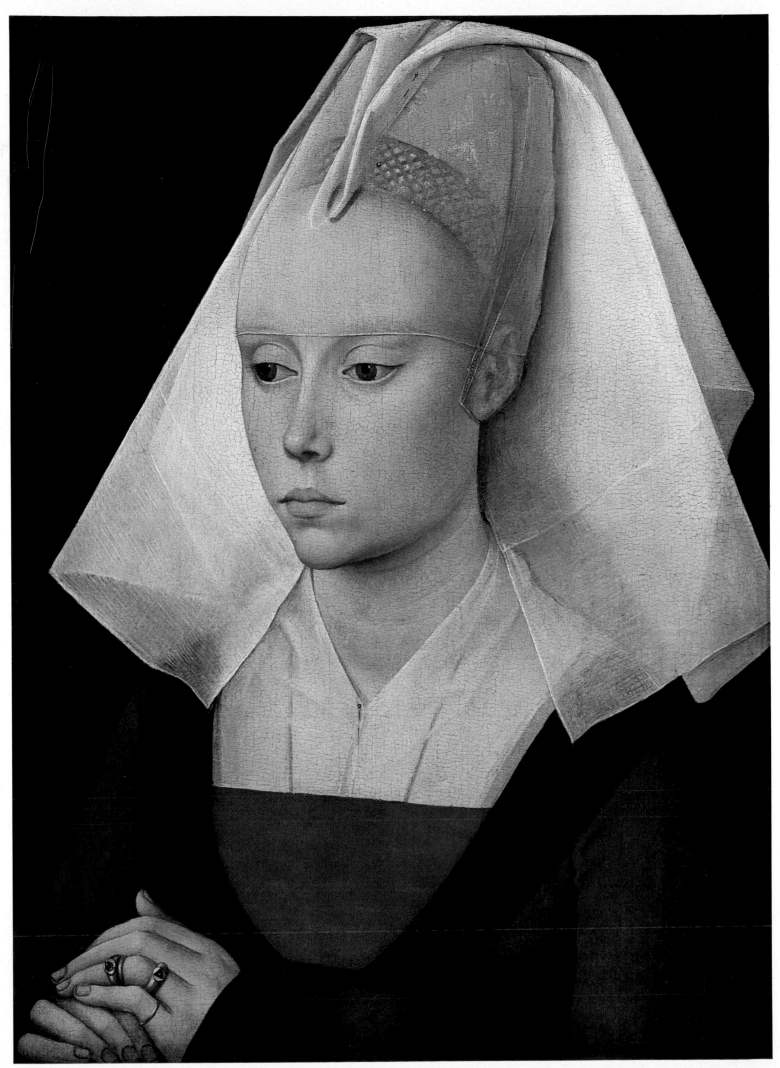

11. ROGIER VAN DER WEYDEN: *Portrait of a Lady*. About 1450–60. London, National Gallery

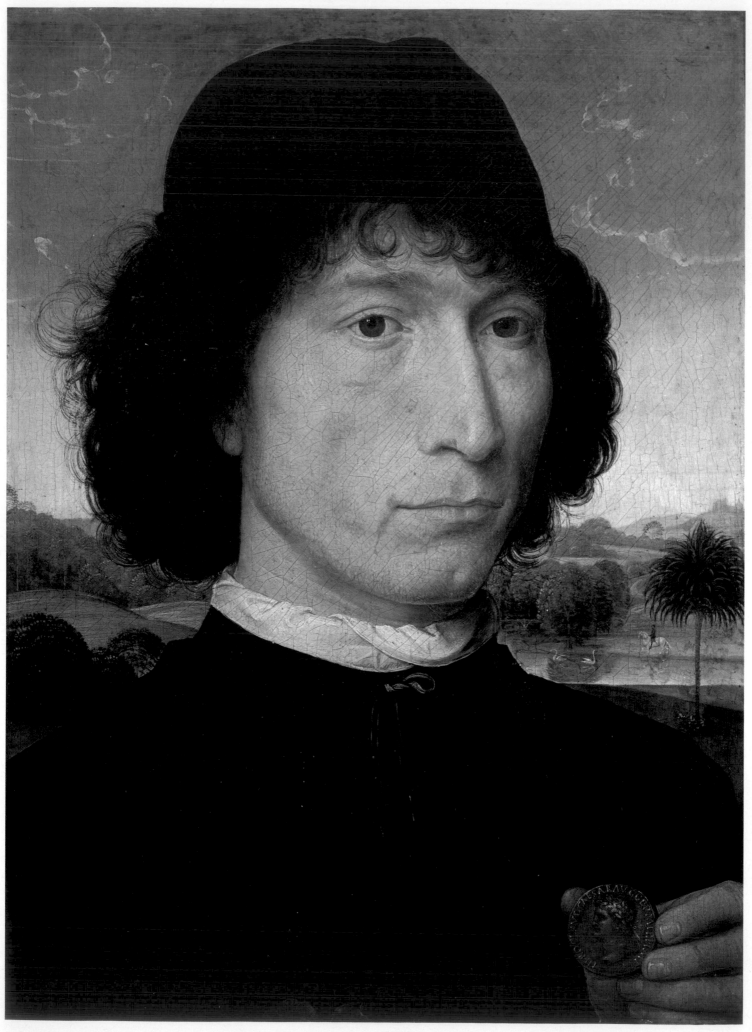

12. HANS MEMLINC (*c.* 1430/40–1494): *Man Holding a Medal.* 1470. Antwerp, Musée Royal des Beaux-Arts

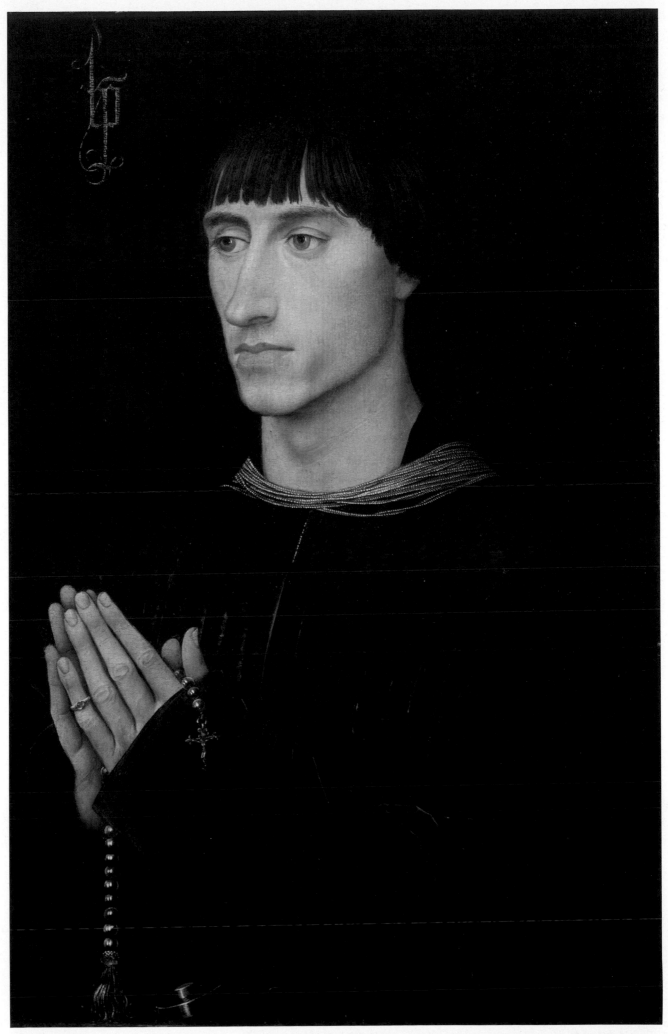

13. ROGIER VAN DER WEYDEN: *Philippe de Croy*. Before 1460/1. Antwerp, Musée Royal des Beaux-Arts

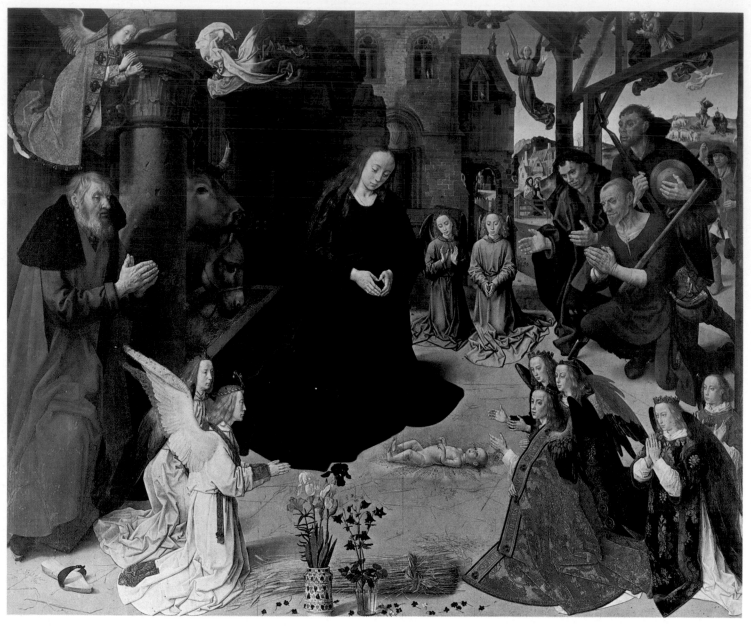

14. HUGO VAN DER GOES (d. 1482): *The Adoration of the Shepherds* (central panel of the 'Portinari Altarpiece'). About 1475. Florence, Uffizi

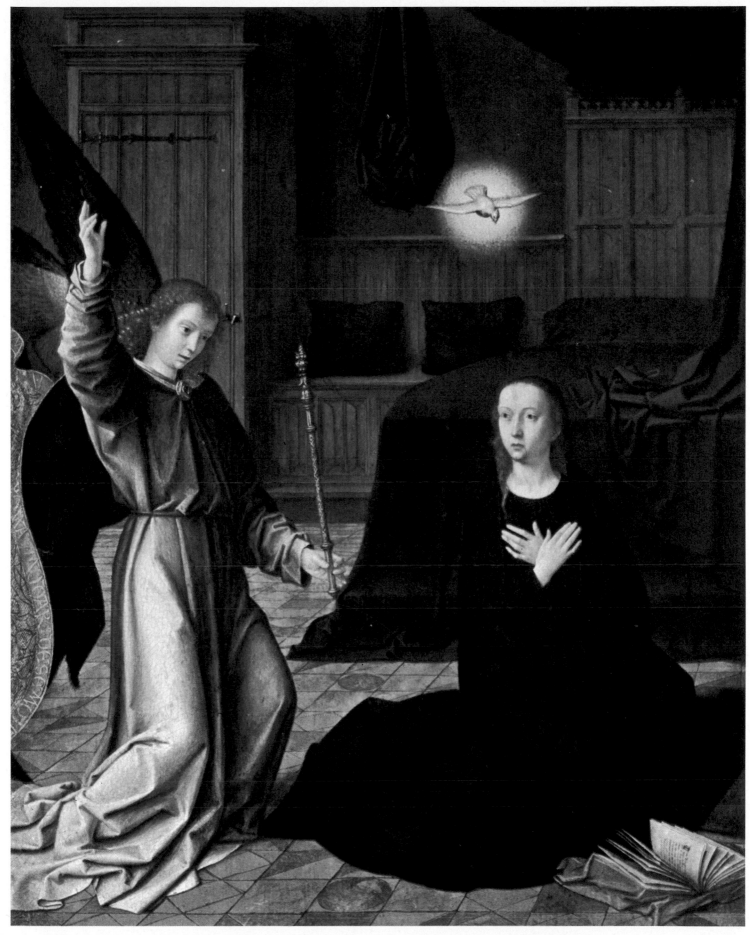

15. GERARD DAVID (d. 1523): *The Annunciation*. Frankfurt, Städelsches Kunstinstitut

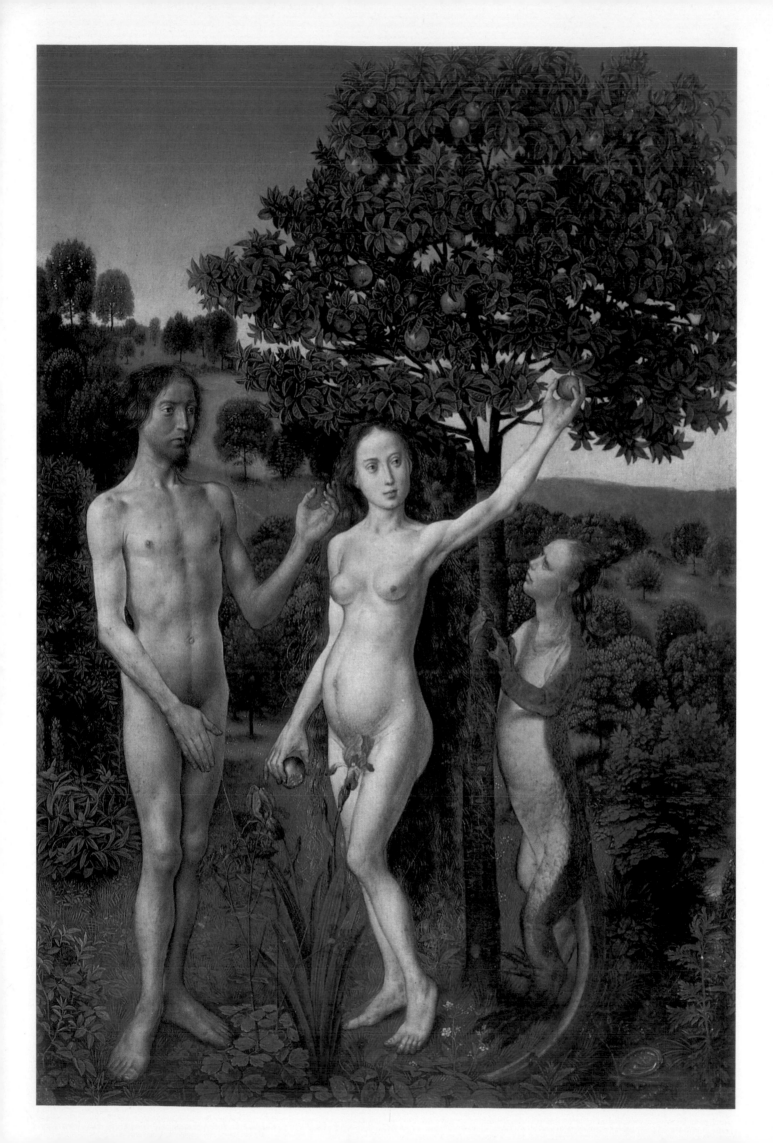

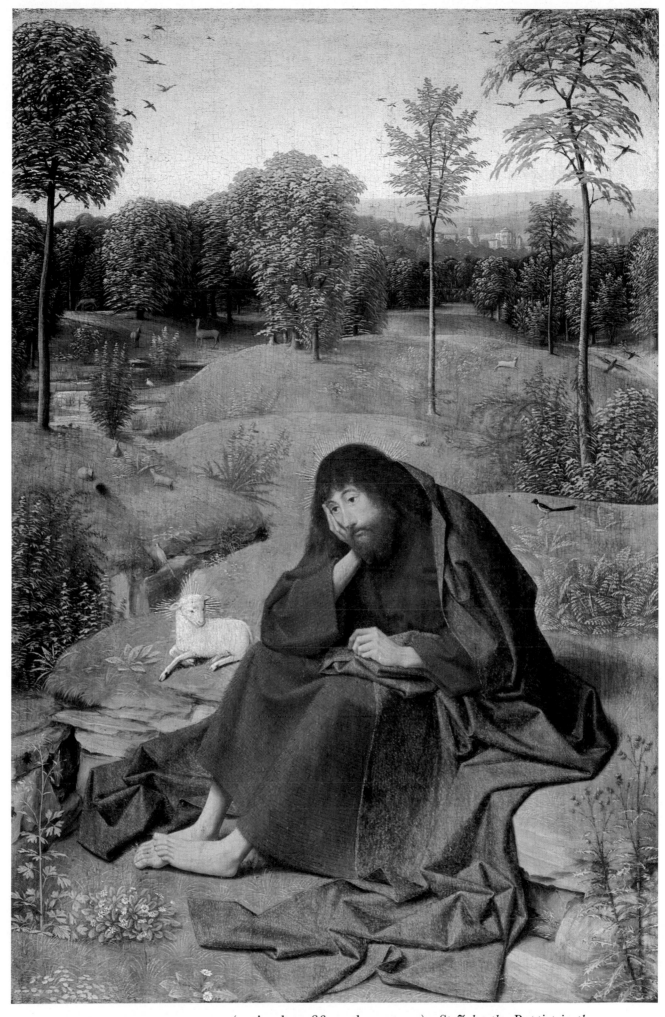

17. GEERTGEN TOT SINT JANS (active late fifteenth century): *St John the Baptist in the Wilderness*. 1480s? Berlin-Dahlem, Staatliche Museen

16. HUGO VAN DER GOES: *The Fall of Man*. About 1470. Vienna, Kunsthistorisches Museum

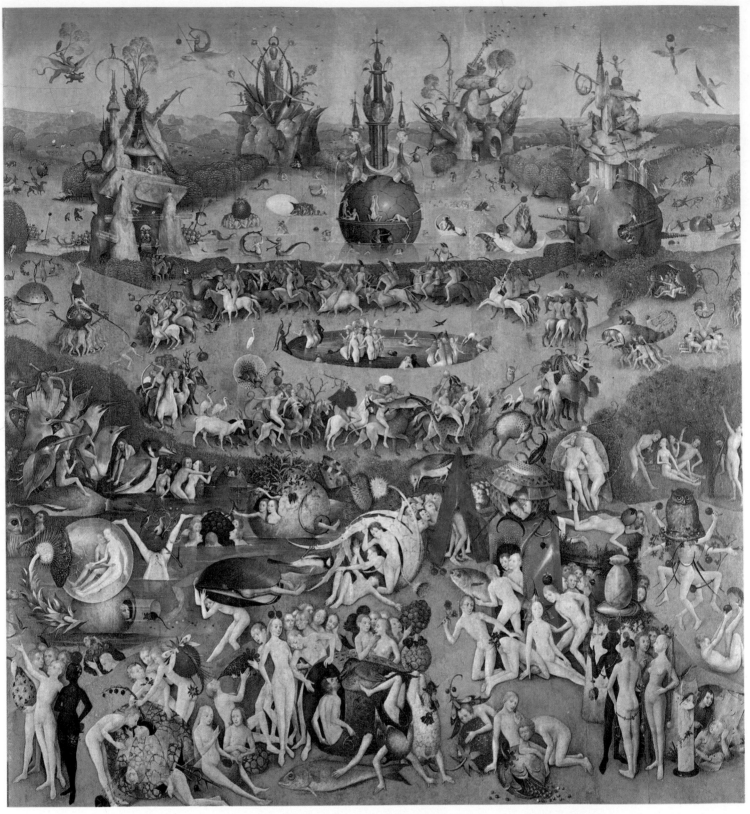

18. HIERONYMUS BOSCH (d. 1516): *The Garden of Earthly Delights* (central panel). About 1505. Madrid, Prado

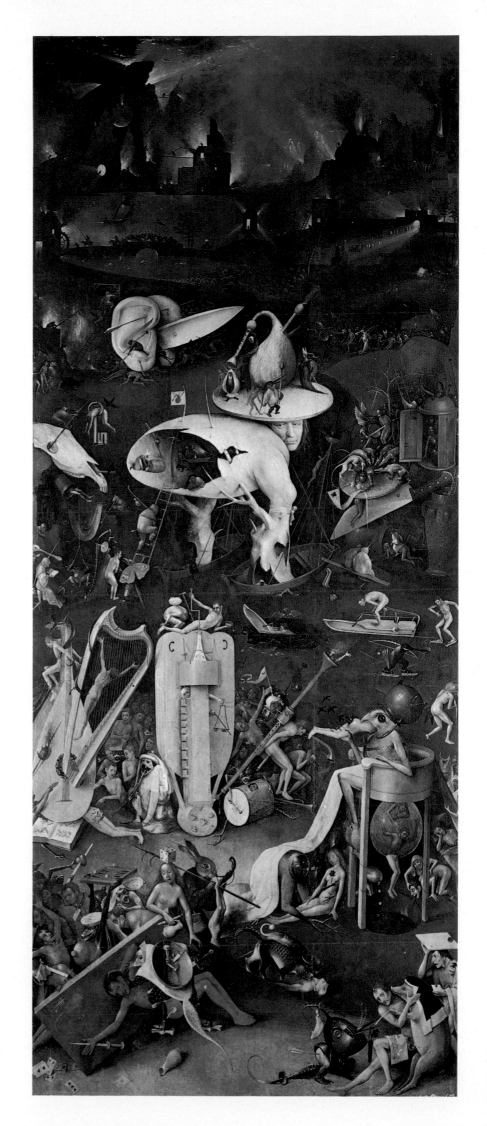

19. HIERONYMUS BOSCH: *The Garden of Earthly Delights* (right wing). About 1505. Madrid, Prado

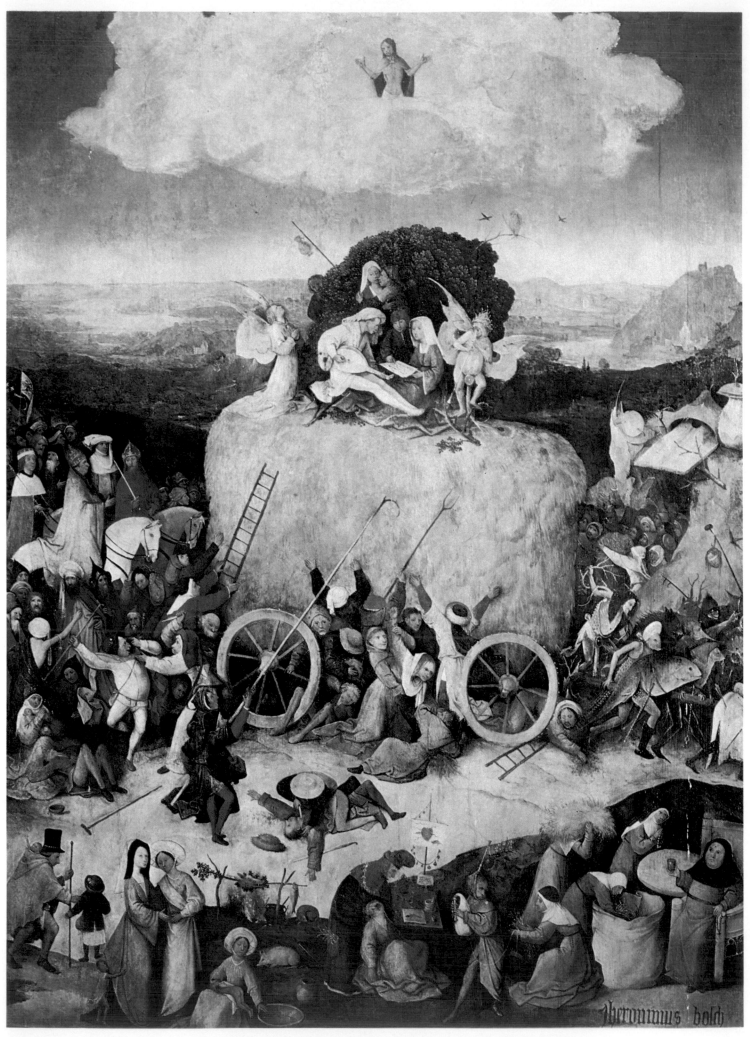

20. HIERONYMUS BOSCH: *The Haywain* (central panel). About 1500. Madrid, Prado

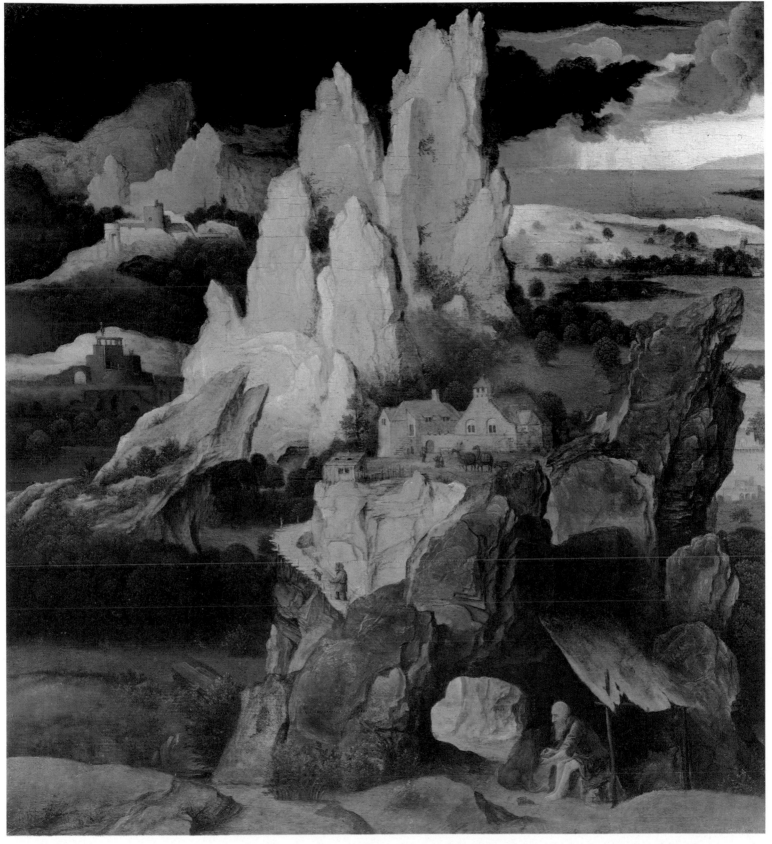

21. Ascribed to JOACHIM PATENIR (d. *c.* 1524): *St Jerome in a Rocky Landscape*. London, National Gallery

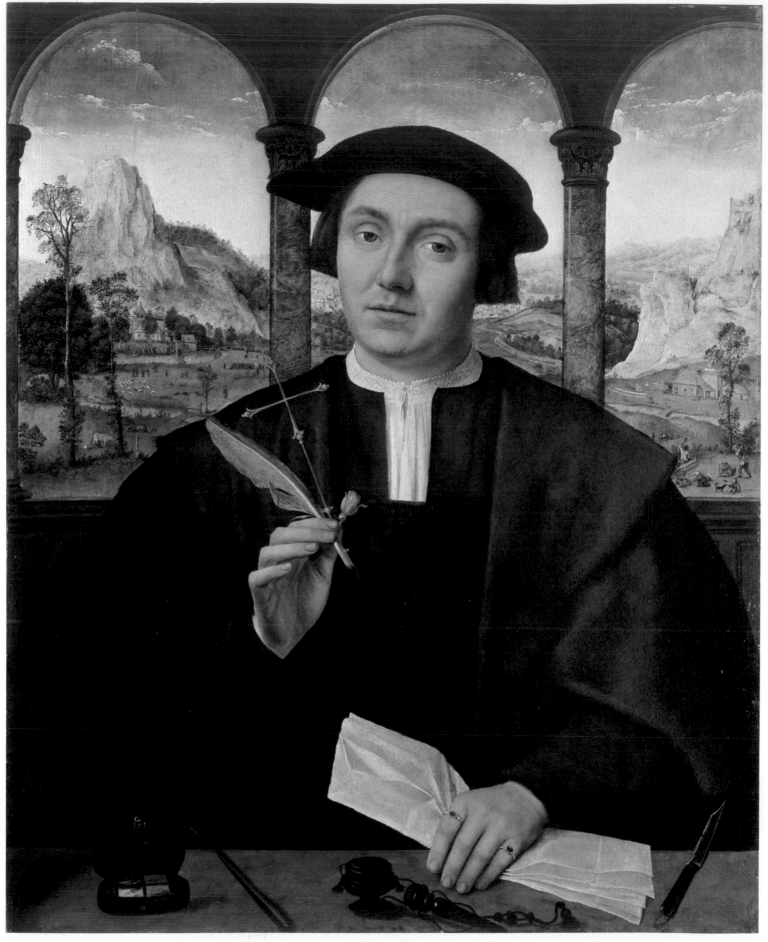

22. QUENTIN MASSYS (1464/5–1530): *Portrait of a Man*. Edinburgh, National Gallery of Scotland

23. JOOS VAN CLEVE (d. 1540/1): *Margaretha Boghe*. About 1530. Washington, National Gallery of Art

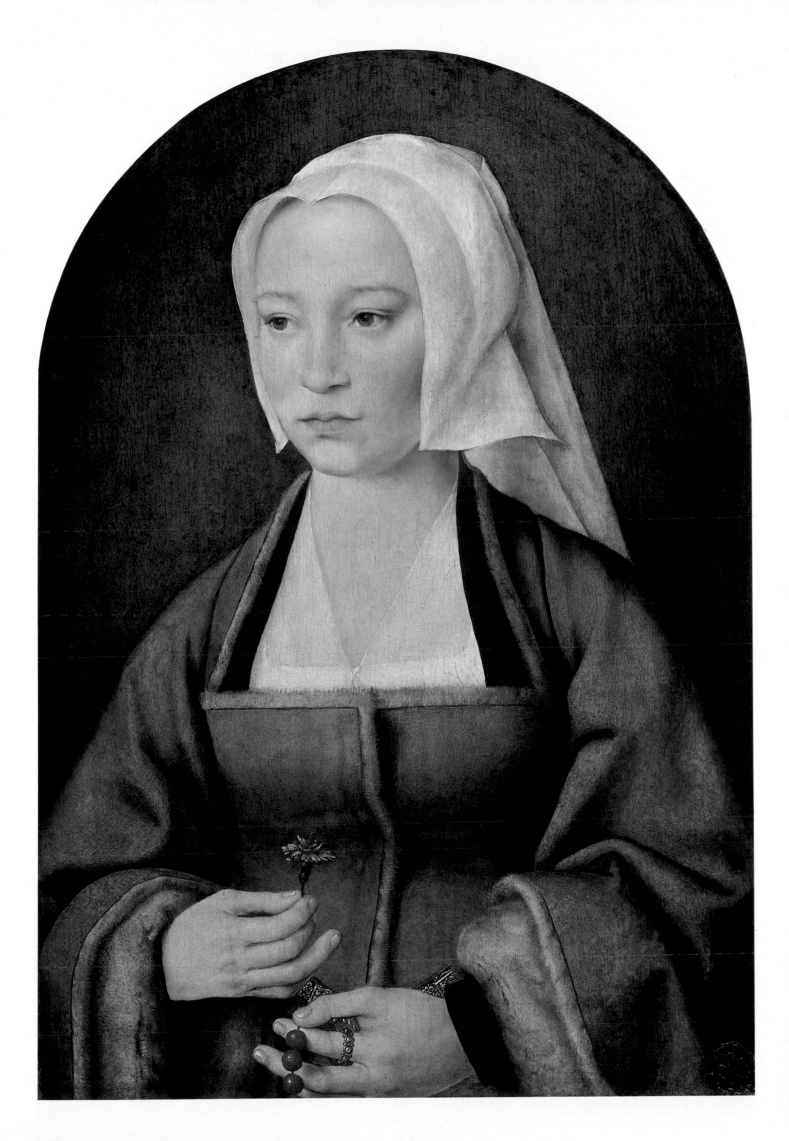

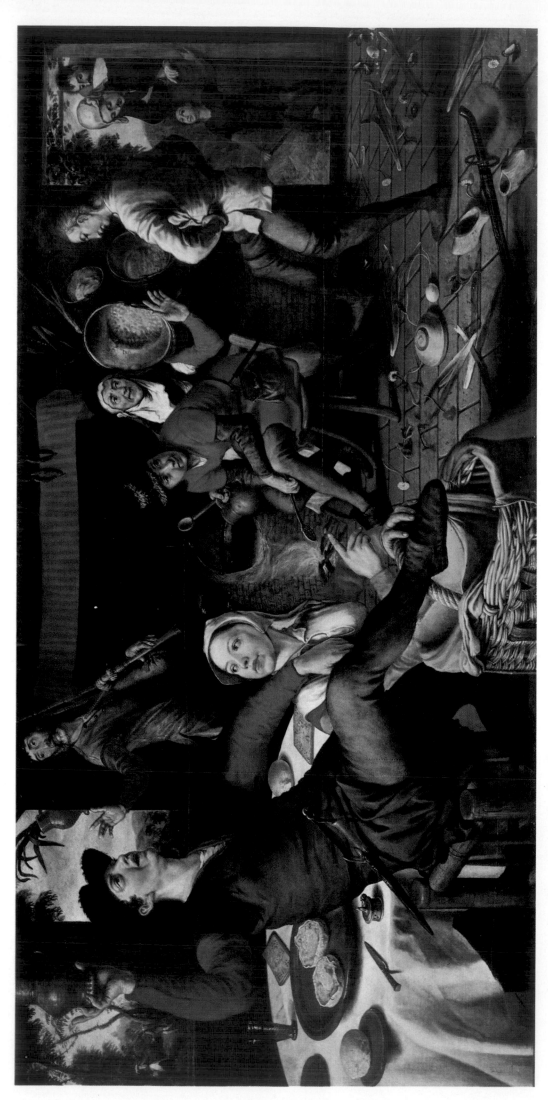

24. PIETER AERTSEN (1508/9-1575): *The Egg Dance*. 1557. Amsterdam, Rijksmuseum

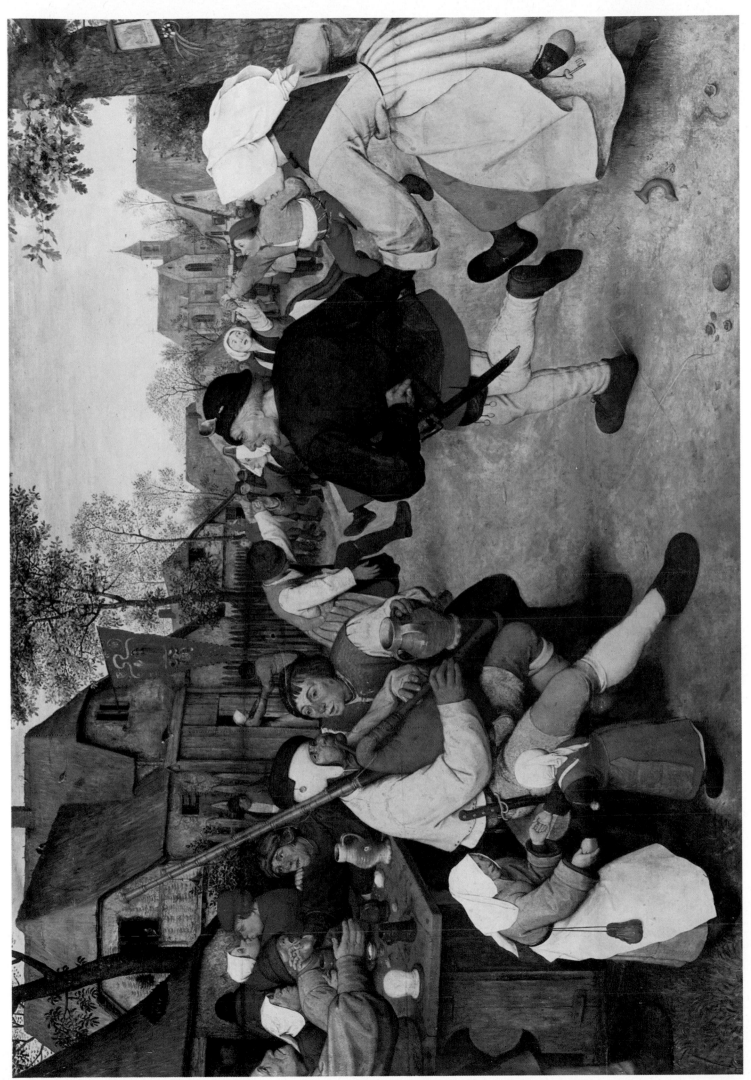

25. PIETER BRUEGEL THE ELDER (d. 1569): *The Peasant Dance*. About 1567–8. Vienna, Kunsthistorisches Museum

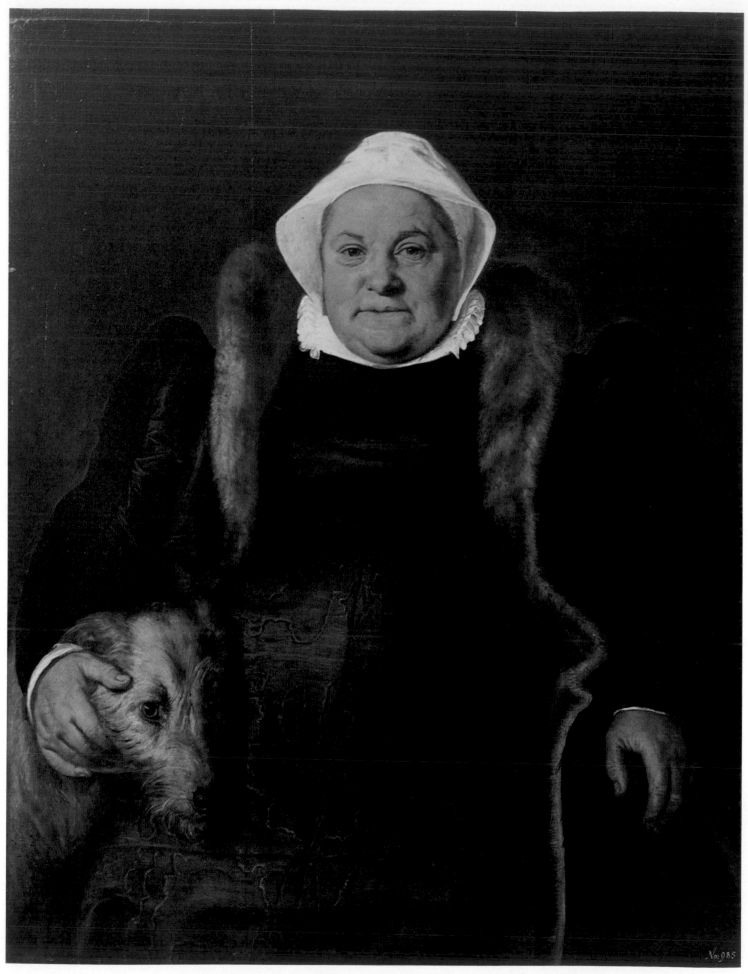

26. FRANS FLORIS (*c.* 1517–70): *Portrait of an Elderly Woman.* 1558. Caen, Musée des Beaux-Arts

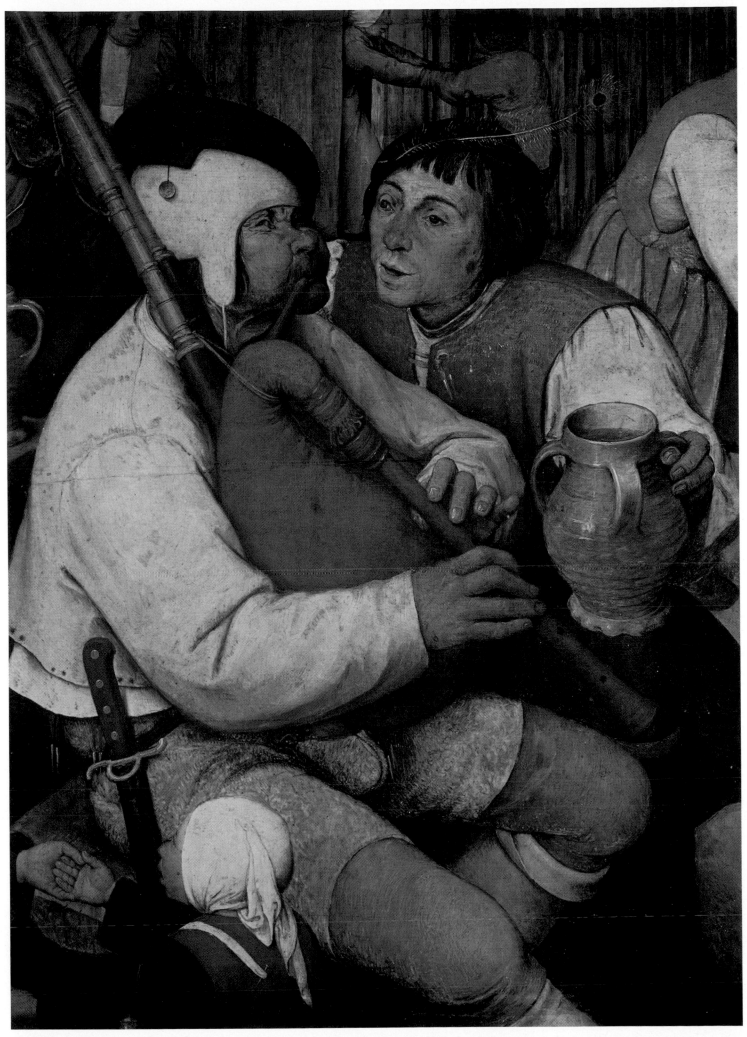

27. PIETER BRUEGEL THE ELDER: Detail from *The Peasant Dance* (Plate 25)

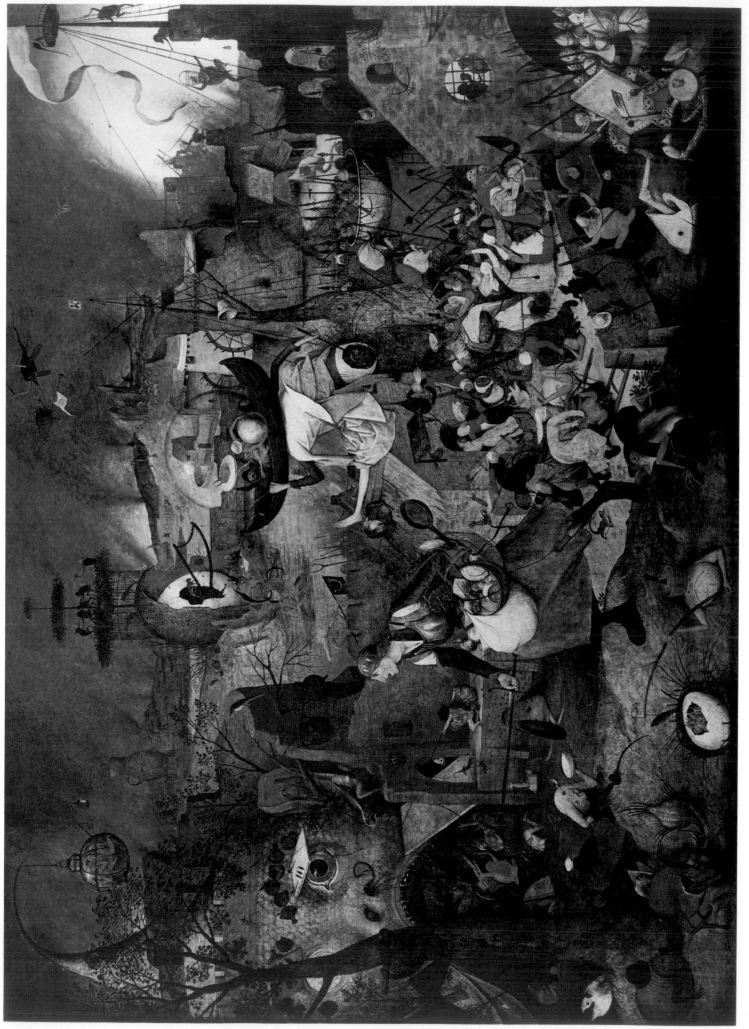

28. PIETER BRUEGEL THE ELDER: *Dulle Griet* (Mad Meg). 1562. Antwerp, Museum Mayer van den Bergh

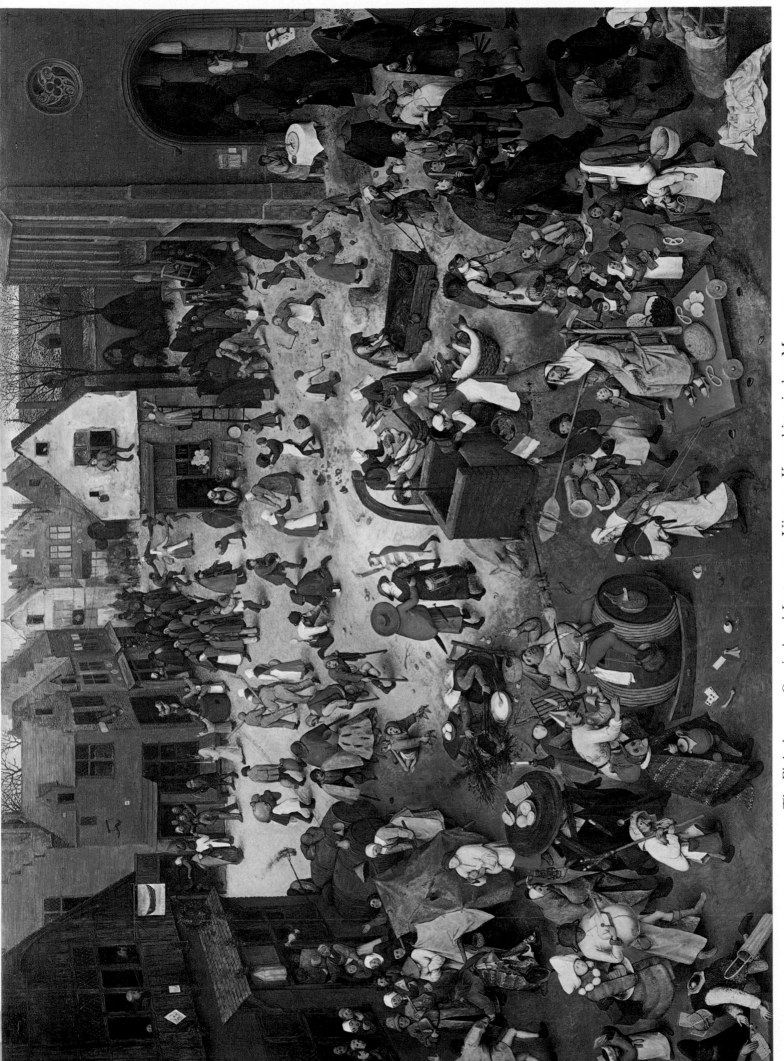

29. PIETER BRUEGEL THE ELDER: *The Fight between Carnival and Lent.* 1559. Vienna, Kunsthistorisches Museum

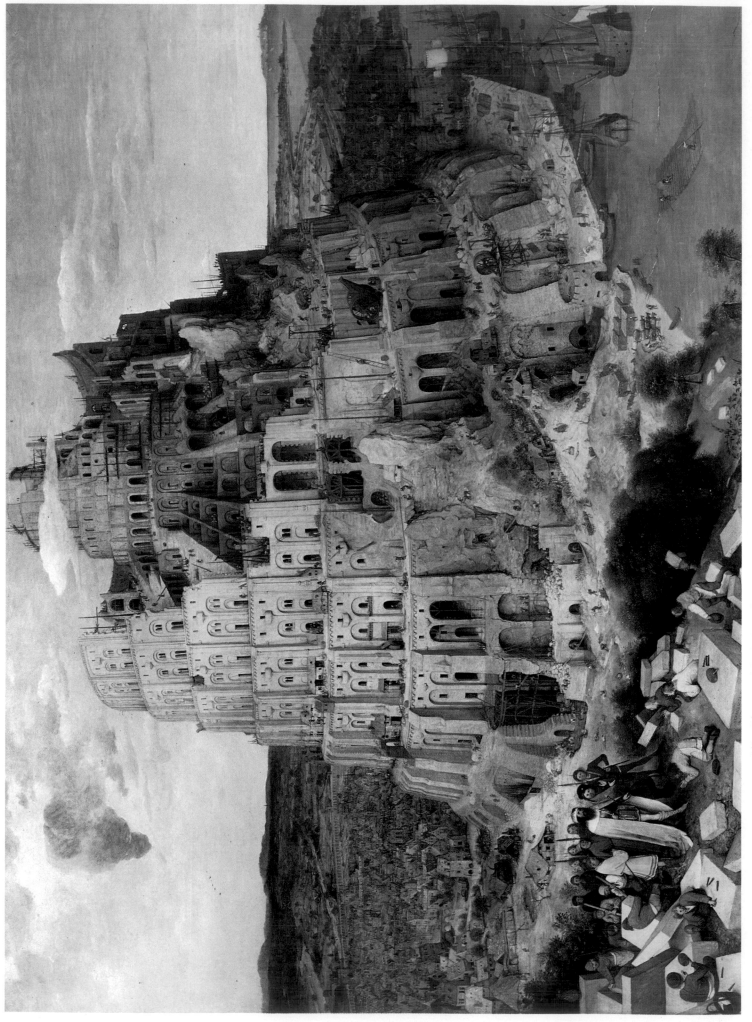

30. PIETER BRUEGEL THE ELDER: *The Tower of Babel.* 1563. Vienna, Kunsthistorisches Museum

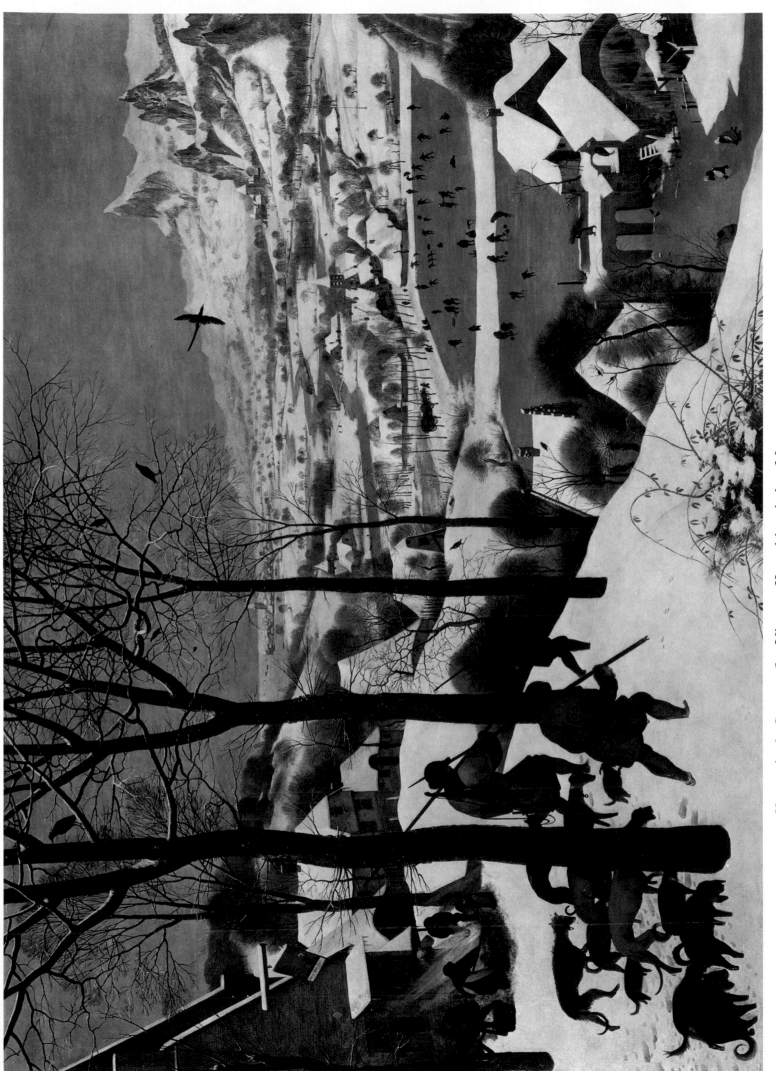

31. PIETER BRUEGEL THE ELDER: *Hunters in the Snow.* 1565. Vienna, Kunsthistorisches Museum

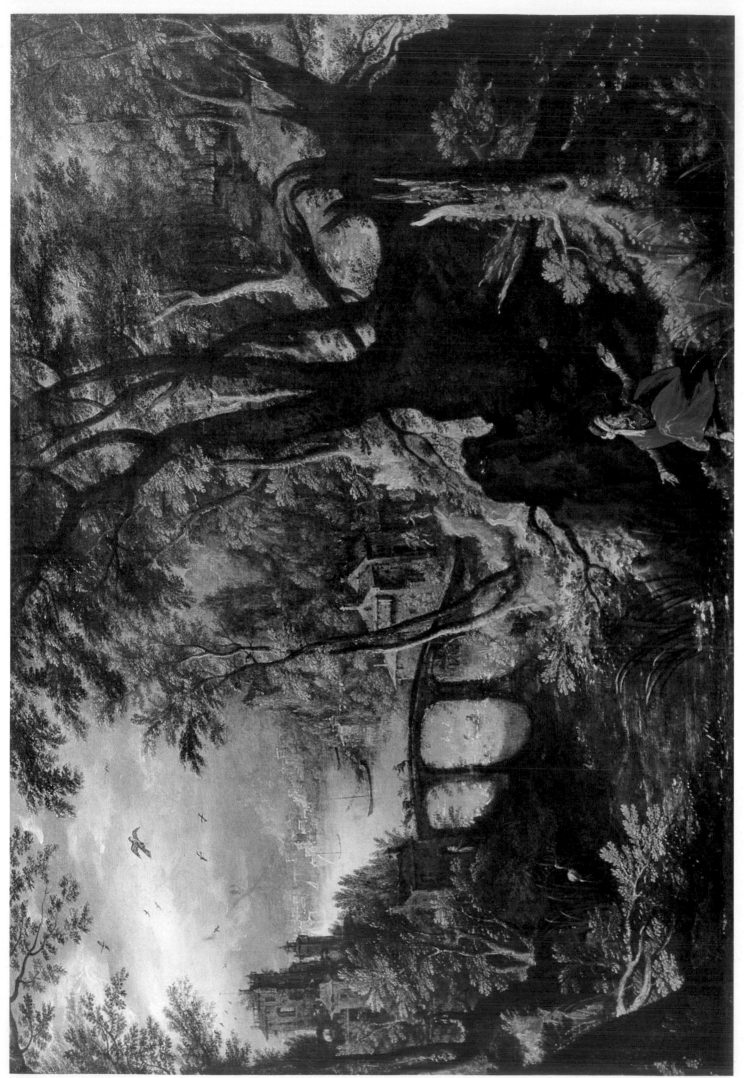

32. GILLIS VAN CONINXLOO (1544–1607): *Landscape with Elijah*. Brussels, Musées Royaux des Beaux-Arts

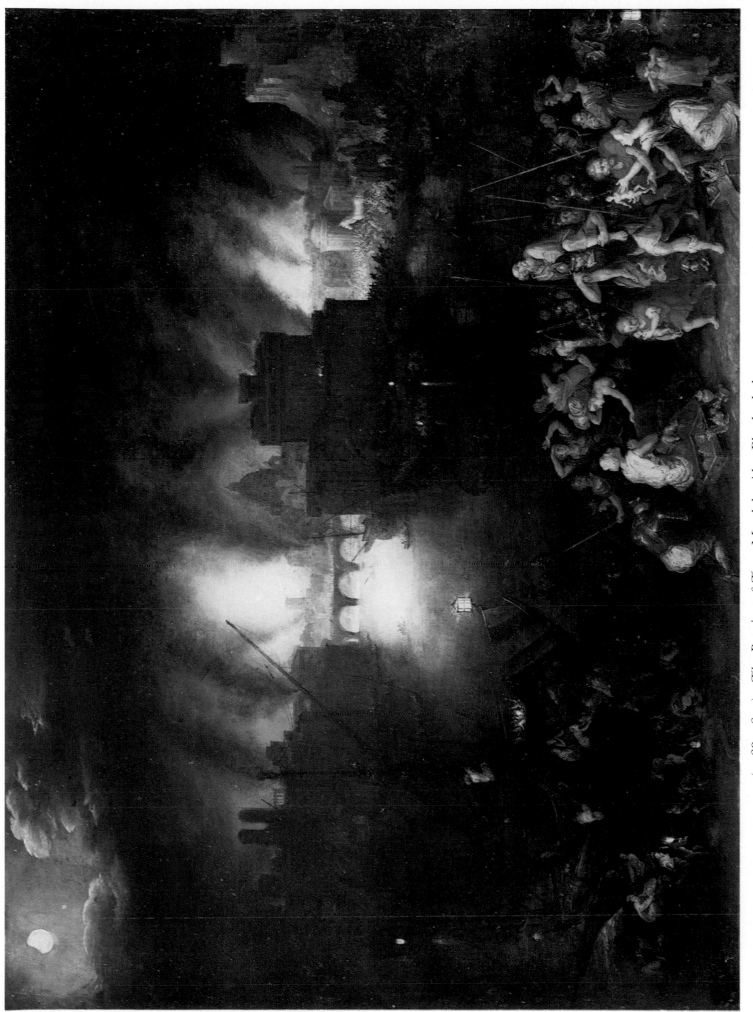

33. JAN BRUEGHEL THE ELDER (1568–1625): *The Burning of Troy*. Munich, Alte Pinakothek

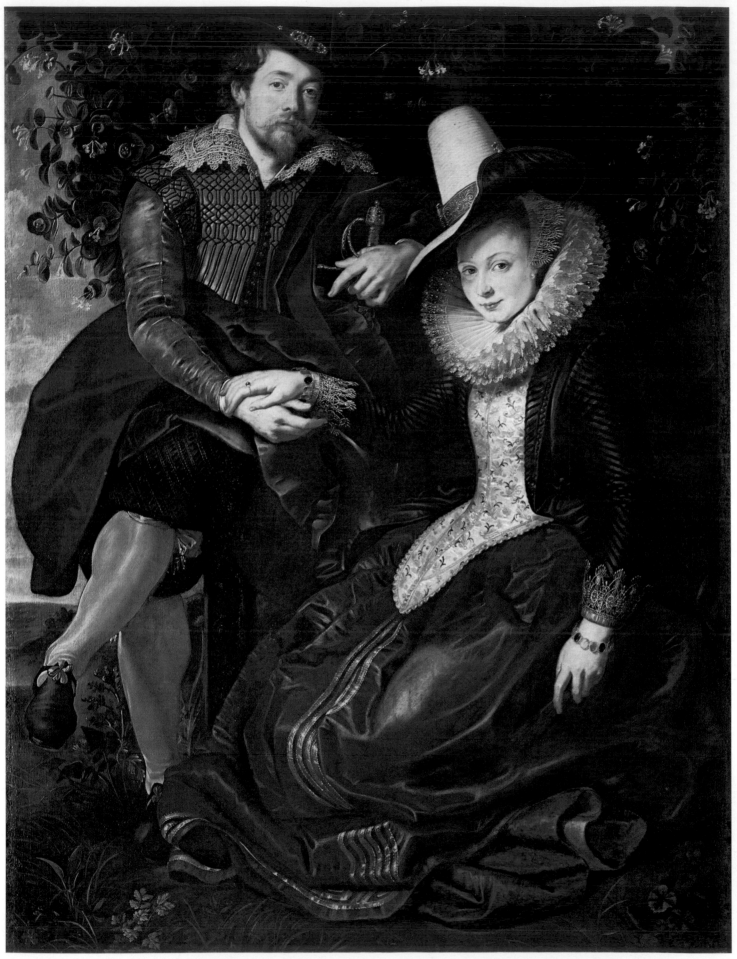

34. SIR PETER PAUL RUBENS (1577–1640): *Rubens and his Wife, Isabella, in the Honeysuckle Arbour.* 1609–10. Munich, Alte Pinakothek

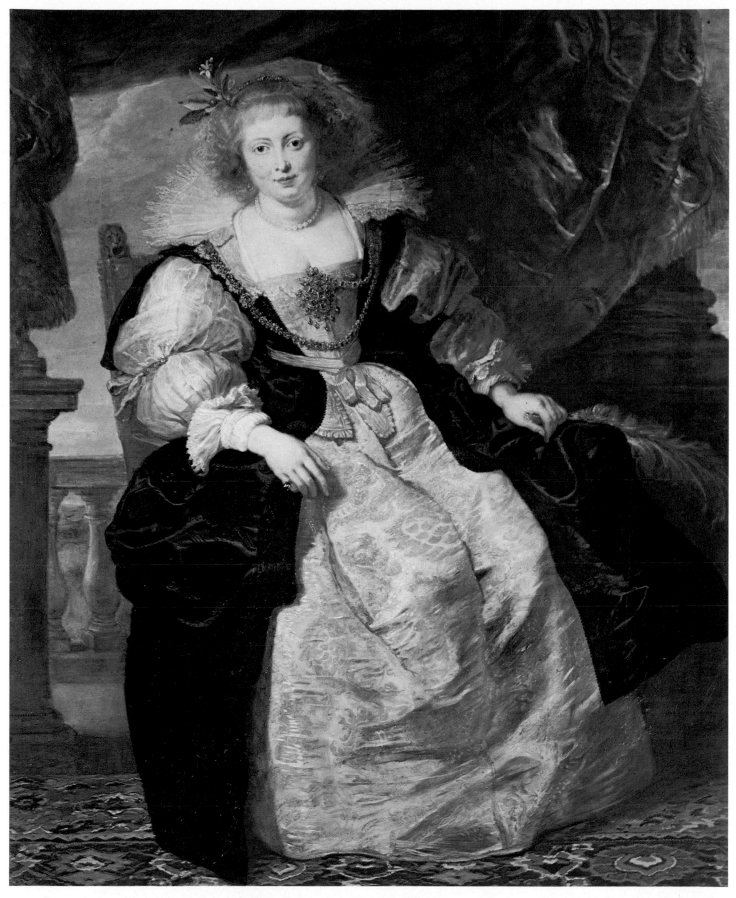

35. SIR PETER PAUL RUBENS: *Hélène Fourment in her Wedding Dress*. 1630–2. Munich, Alte Pinakothek

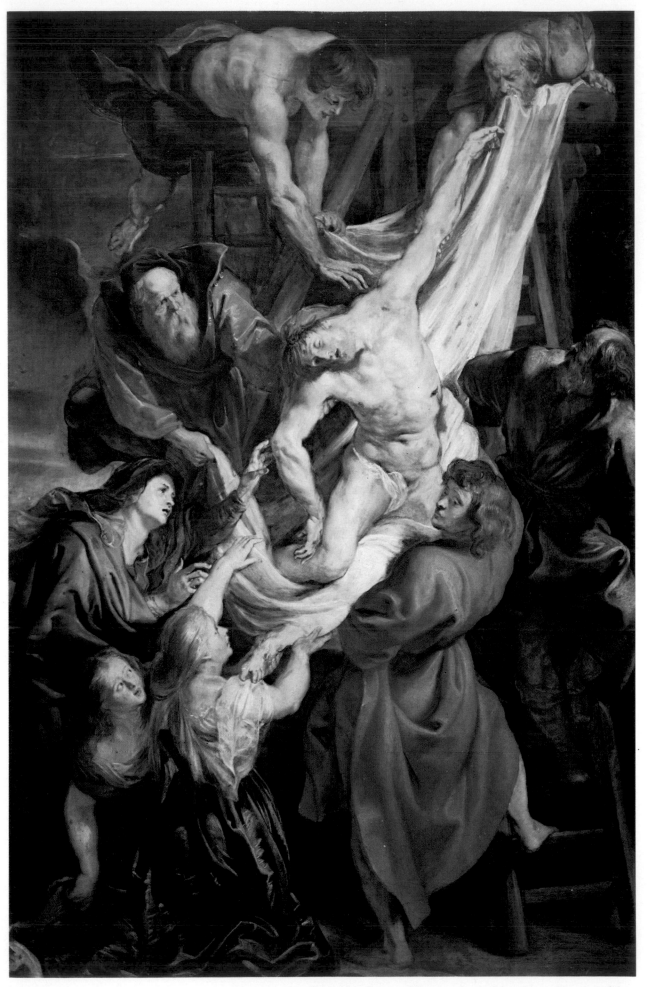

36. SIR PETER PAUL RUBENS: *The Descent from the Cross*. About 1611. London, Courtauld
Institute Galleries

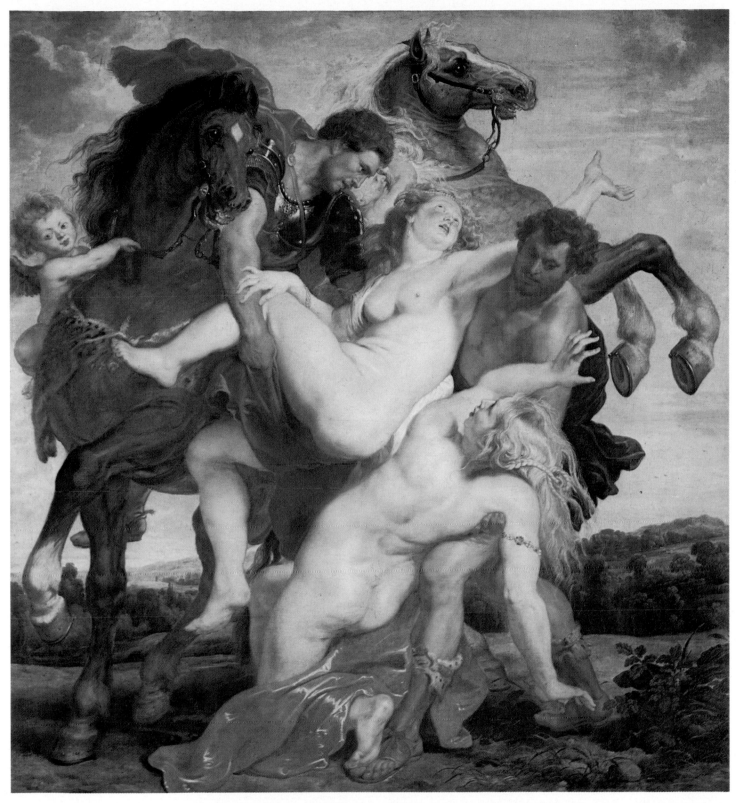

37. SIR PETER PAUL RUBENS: *The Rape of the Daughters of Leucippus*. About 1618. Munich, Alte Pinakothek

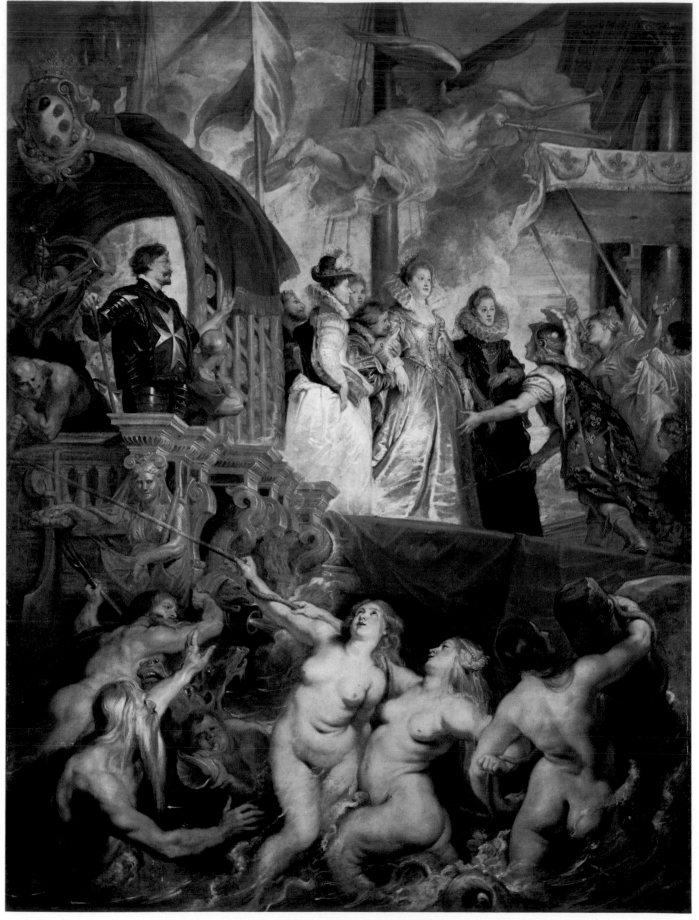

38. SIR PETER PAUL RUBENS: *The Reception of Marie de' Medici at Marseilles.* 1622–5. Paris, Louvre

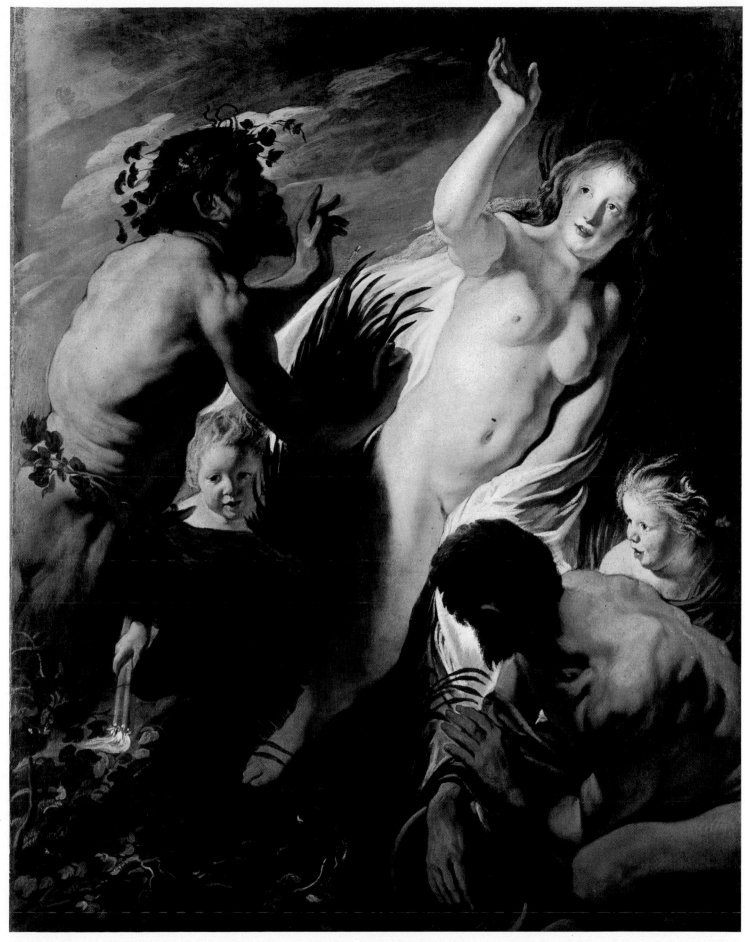

39. JACOB JORDAENS (1593–1678): *Pan and Syrinx*. About 1625. Brussels, Musées Royaux des Beaux-Arts

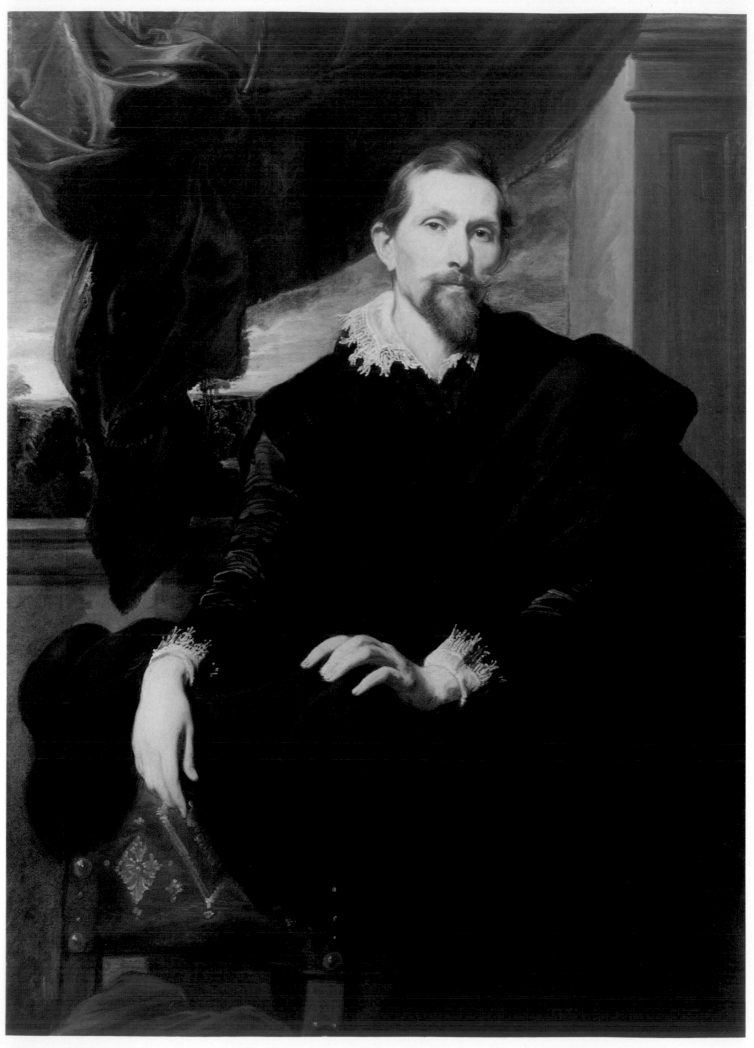

40. SIR ANTHONY VAN DYCK (1599–1641): *Frans Snyders*. About 1620. New York, Frick Collection

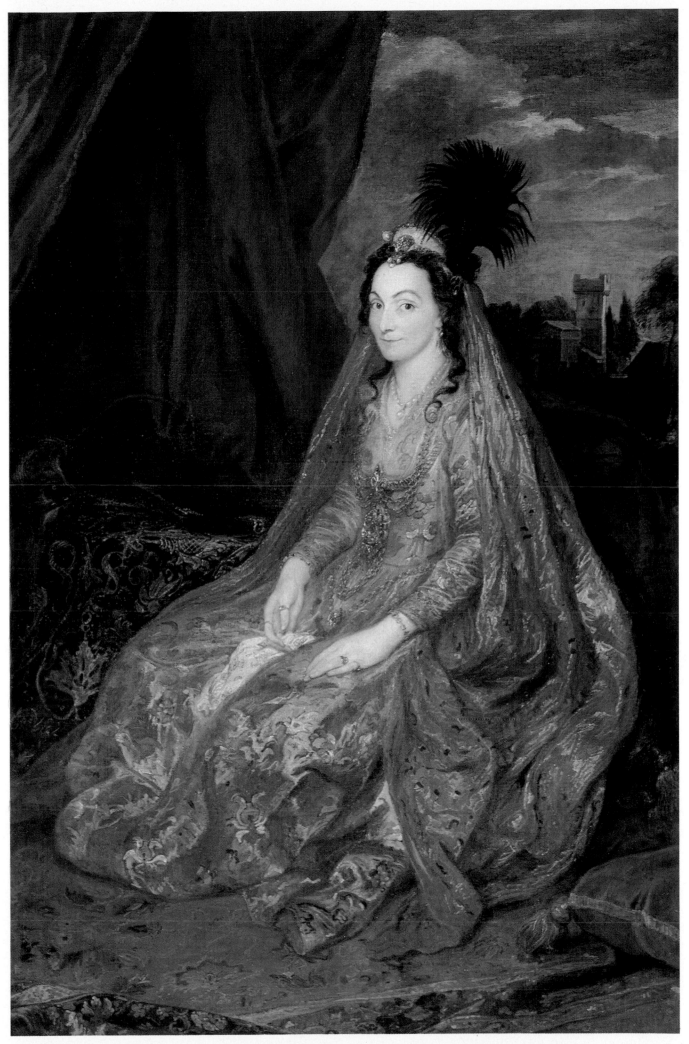

41. SIR ANTHONY VAN DYCK: *Lady Shirley*. 1622. Sussex, Petworth House, The National Trust

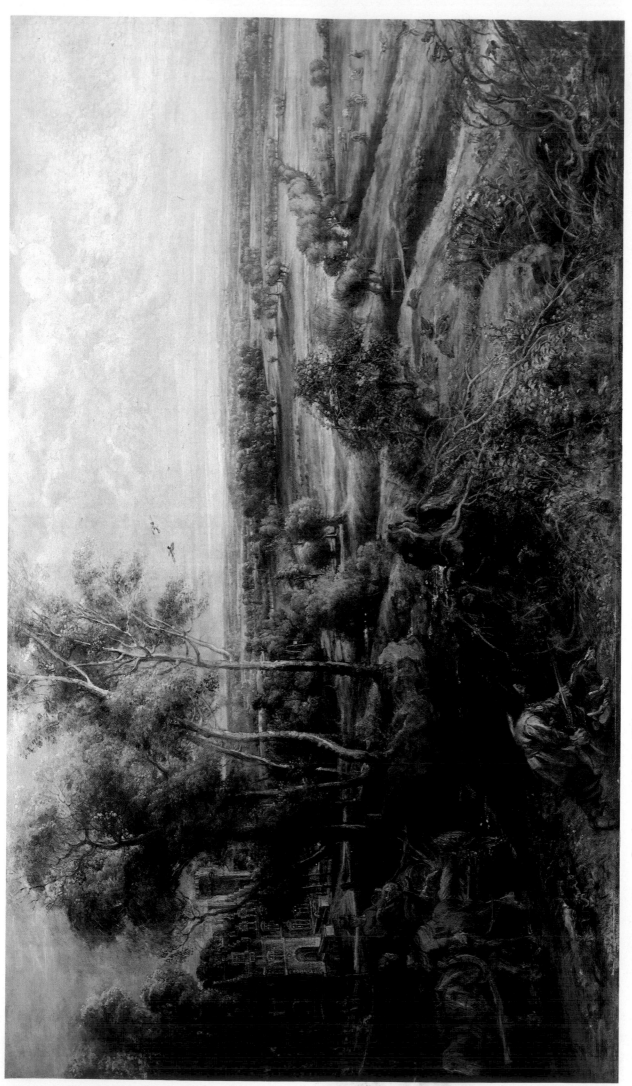

42. SIR PETER PAUL RUBENS: *Landscape with the Château of Steen. About 1636. London, National Gallery*

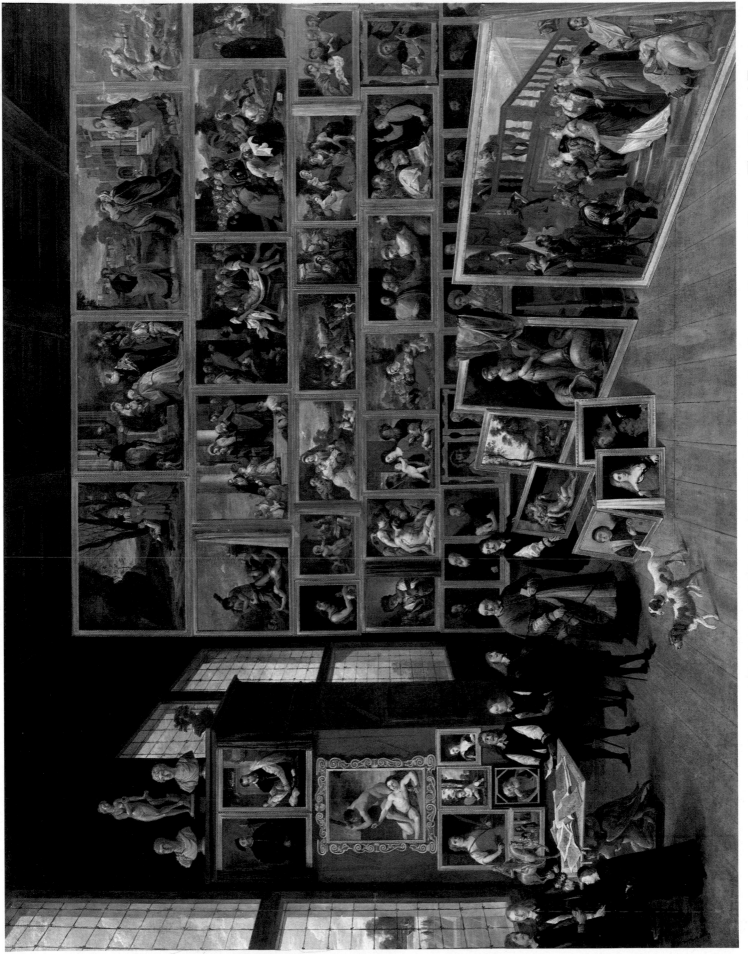

43. DAVID TENIERS THE YOUNGER (1610–90): *Archduke Leopold-Wilhelm's Gallery*. 1651. Sussex, Petworth House, The National Trust

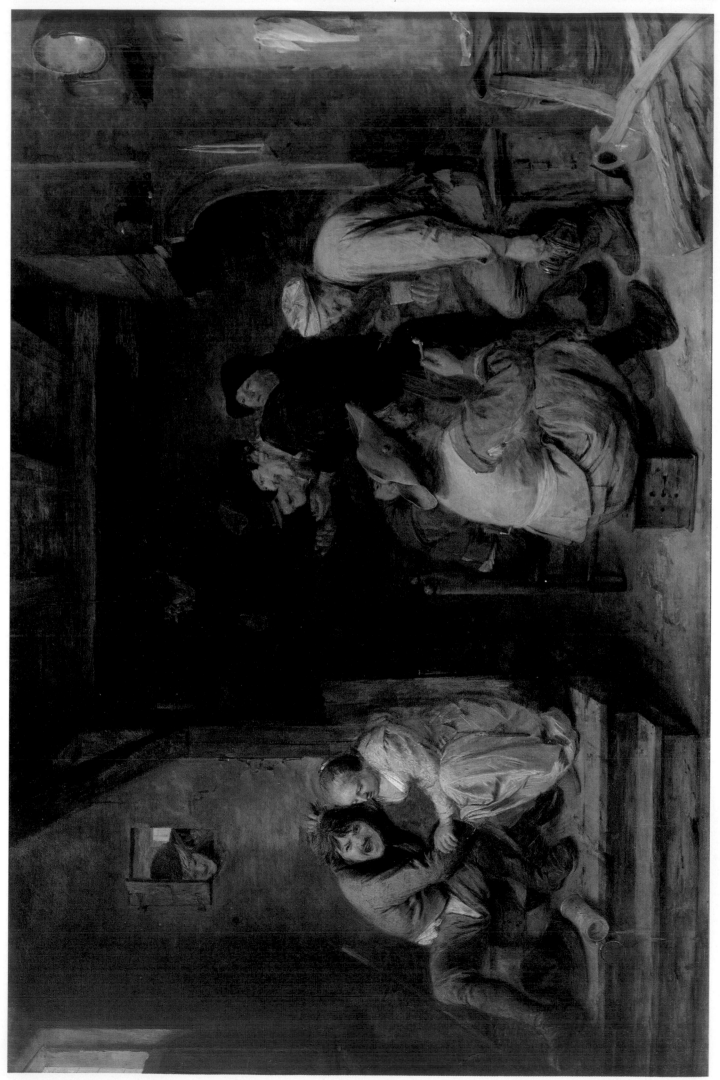

44. ADRIAEN BROUWER (1606?–38): *Tavern Scene*. About 1630. London, National Gallery, on loan from a private collection

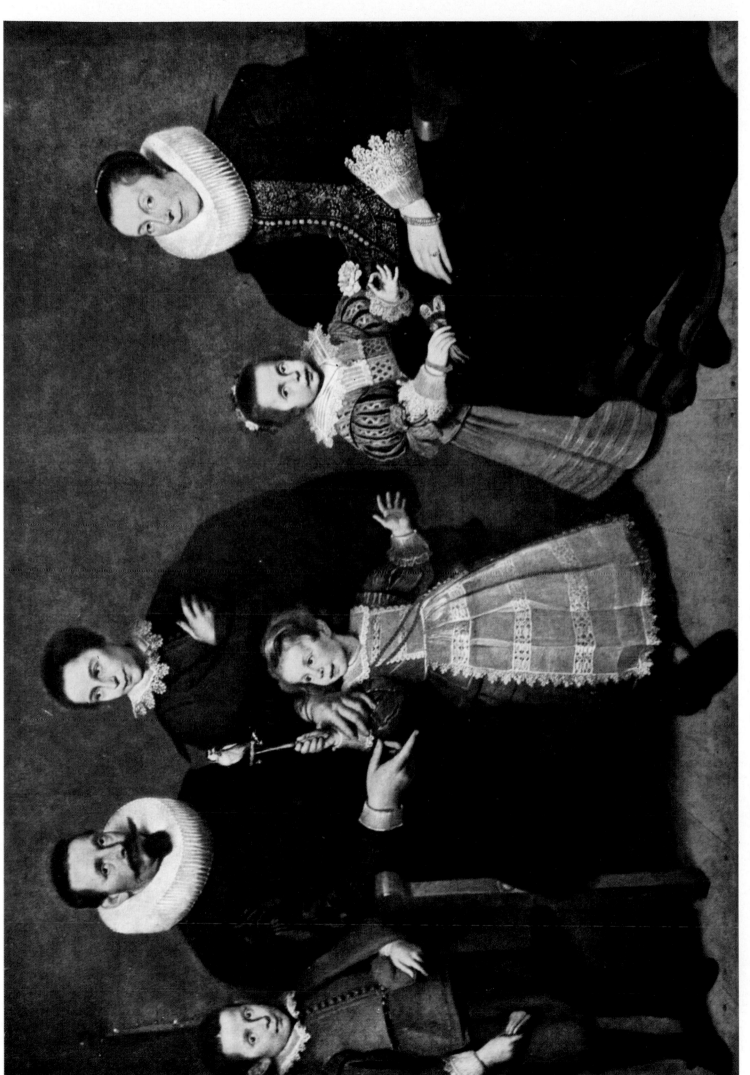

45. CORNELIS DE VOS (1584–1651): *Family Group*. 1631. Antwerp, Musée Royal des Beaux-Arts

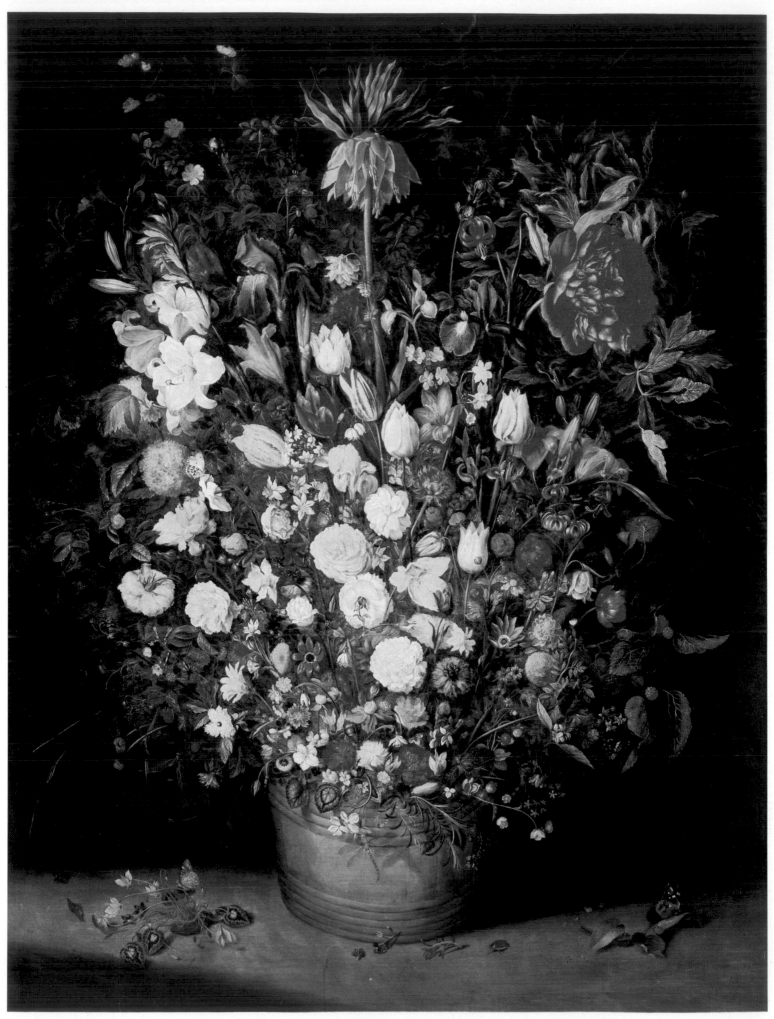

46. JAN BRUEGHEL THE ELDER: *Large Bouquet of Flowers in a Tub*. About 1610? Munich, Alte Pinakothek

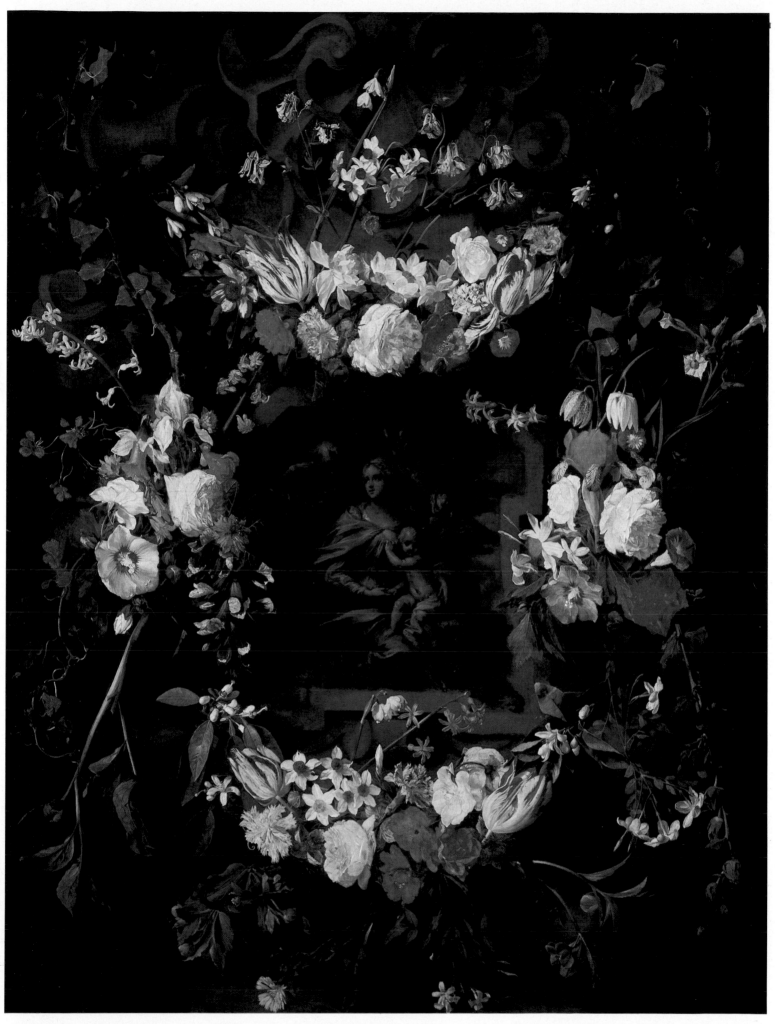

47. DANIEL SEGHERS (1590–1661) and FRANS (?) DENYS (active 1650): *Garland of Flowers with the Holy Family*. About 1650? Antwerp, Musée Royal des Beaux-Arts

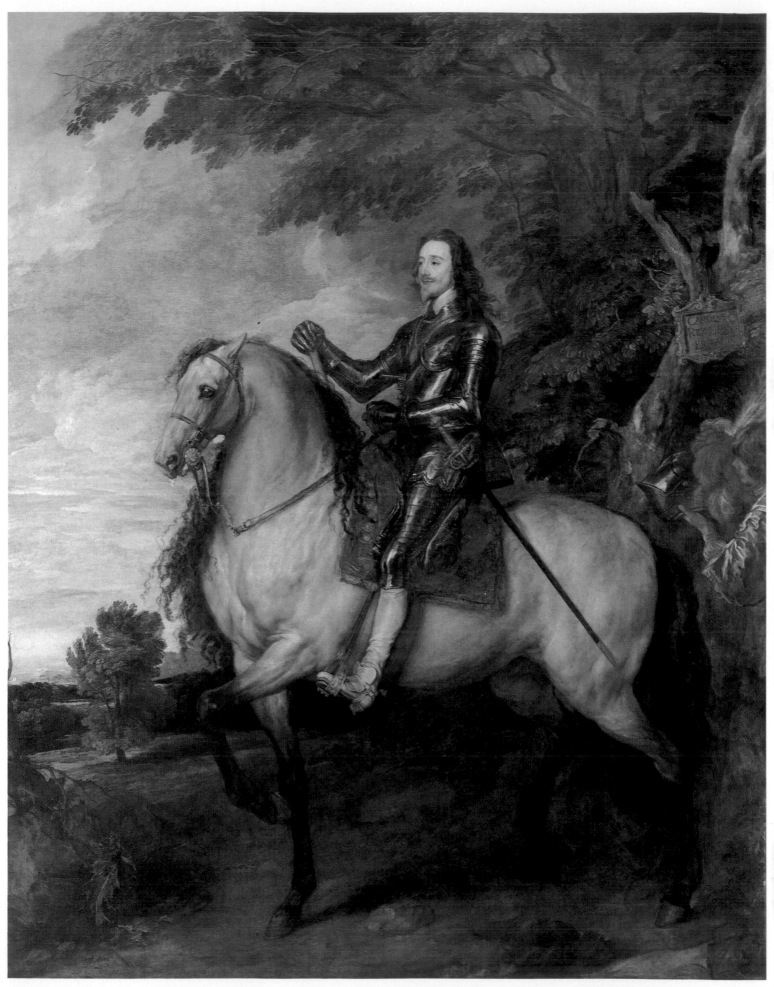

48. SIR ANTHONY VAN DYCK: *Equestrian Portrait of Charles I*. Late 1630s? London, National Gallery